MARCUS
SCHENKENBERG
NEW RULES

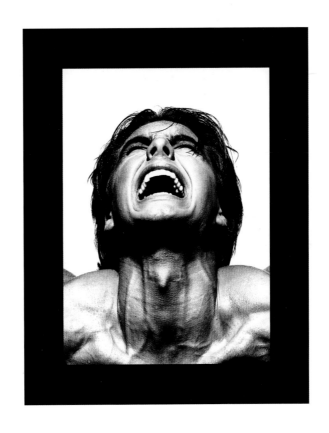

UNIVERSE

First published in the United States of America in 1997
by UNIVERSE PUBLISHING
A Division of Rizzoli International Publications, Inc.
300 Park Avenue South
New York, NY 10010

97 98 99 / 10 9 8 7 6 5 4 3 2 1

Library of Congress Catalog Card Number:
97-60135

Design by Lee Swillingham and Craig Tilford

Printed in England

Front Cover
PATRIK ANDERSSON
New York, 1997

Back Cover
STEPHANIE PFRIENDER
New York, 1993
Uomo Harper's Bazaar

Endpapers
BRUCE WEBER
San Francisco, 1989
Calvin Klein campaign

Title Page
TYEN
Paris, 1990

Right
PATRIK ANDERSSON
New York, 1997

This book is dedicated to my family and to the memory
of my friends Örjan Jonsson and Gianni Versace.

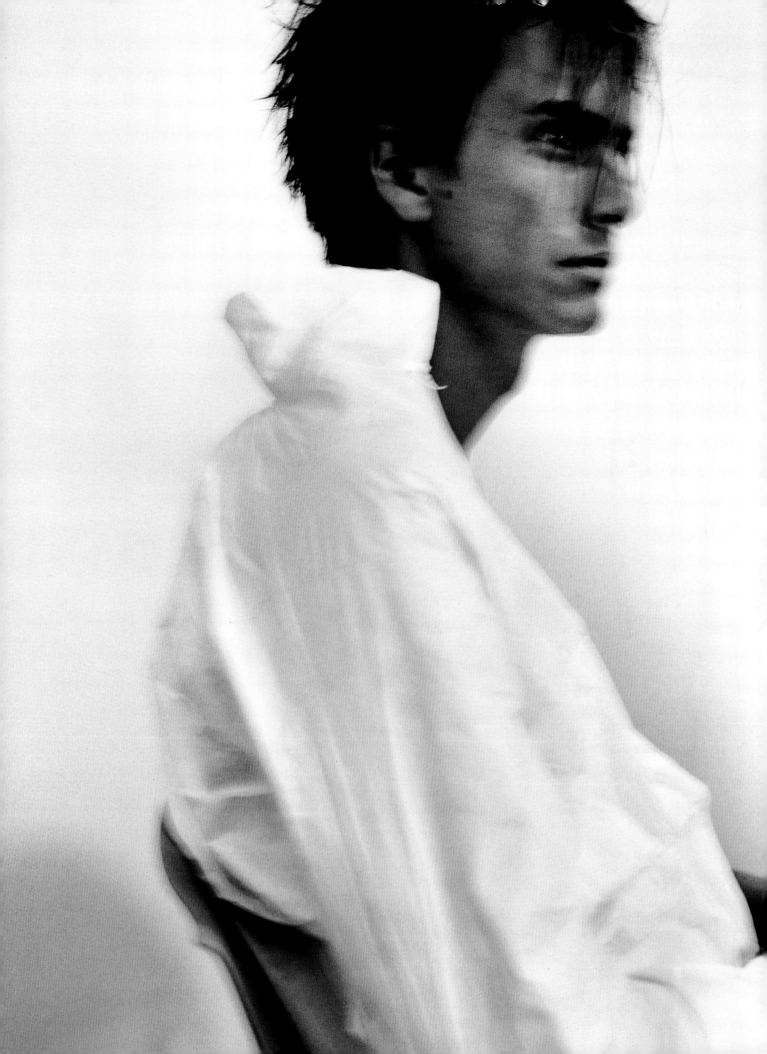

contents:

05

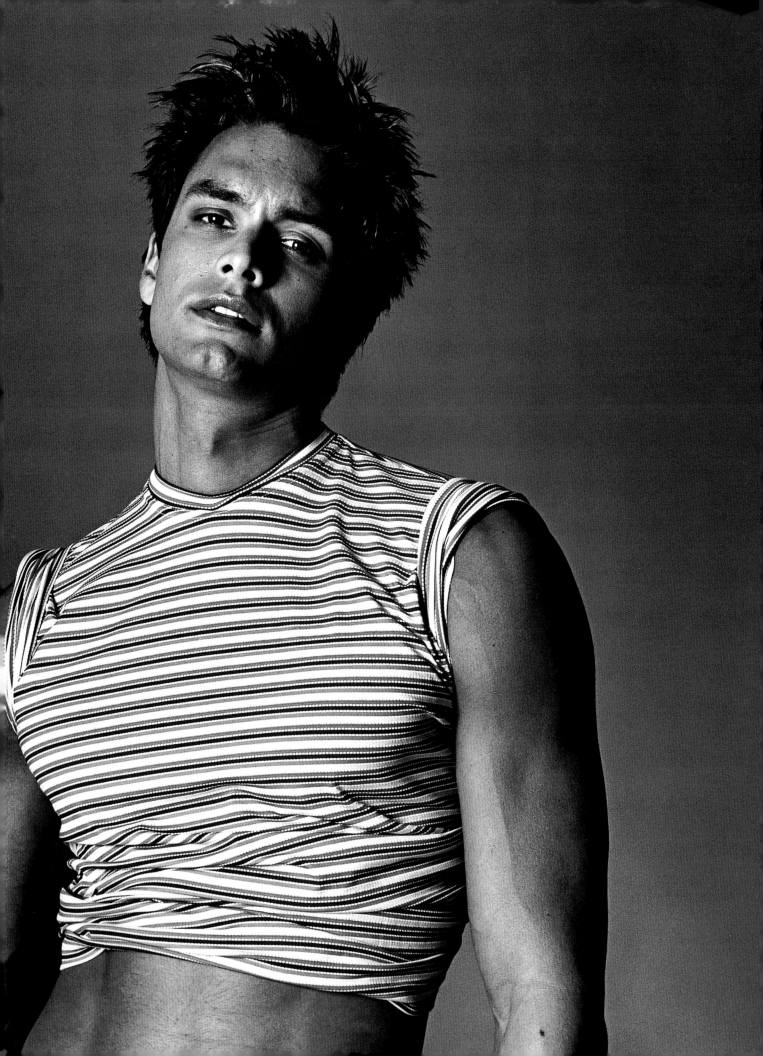

Free Man
Gianni Versace

It is not often that one sees a man like Marcus. He is so comfortable with his body and with himself that he transcends the limits of culture. In this sense, he is free, and by looking at him, you also feel free.

As a designer, I have always found that he brings out the true and utmost potential of the clothes he wears; that's why I want him on the catwalk and in pictures. He has that particular gift to make himself new and to let fashion cover his body every time in a new way.

Photographs of Marcus are unlike those of most models because he is so physical. He knows his body, how to move it, and how to use his energy to give life to pictures . . . some almost explode off the page, like the "flying blanket" for Avedon; others have the sense of a frozen moment in time, like in the advertisements for Absolut. All of them are powerful and expressive. That's one reason why he became the first male model people recognized by name.

After Marcus's first famous pictures, men everywhere grew their hair out like his, paid more attention to their bodies, and to how the clothes actually fit them. Men are taking a cue from Marcus and are feeling comfortable about expanding their self-expression, about being sexy and beautiful. And it's just the beginning. . . .

Gianni Versace

Left
MICHAEL TAMMARO
New York, 1997

This Page
JÖRG REICHARDT
New York, 1993
Jockey, Volma Wirkwaren gmbh

Page 8
KAL YEE
Los Angeles, 1989

Page 9
BRUCE WEBER
San Francisco, 1991
Calvin Klein campaign

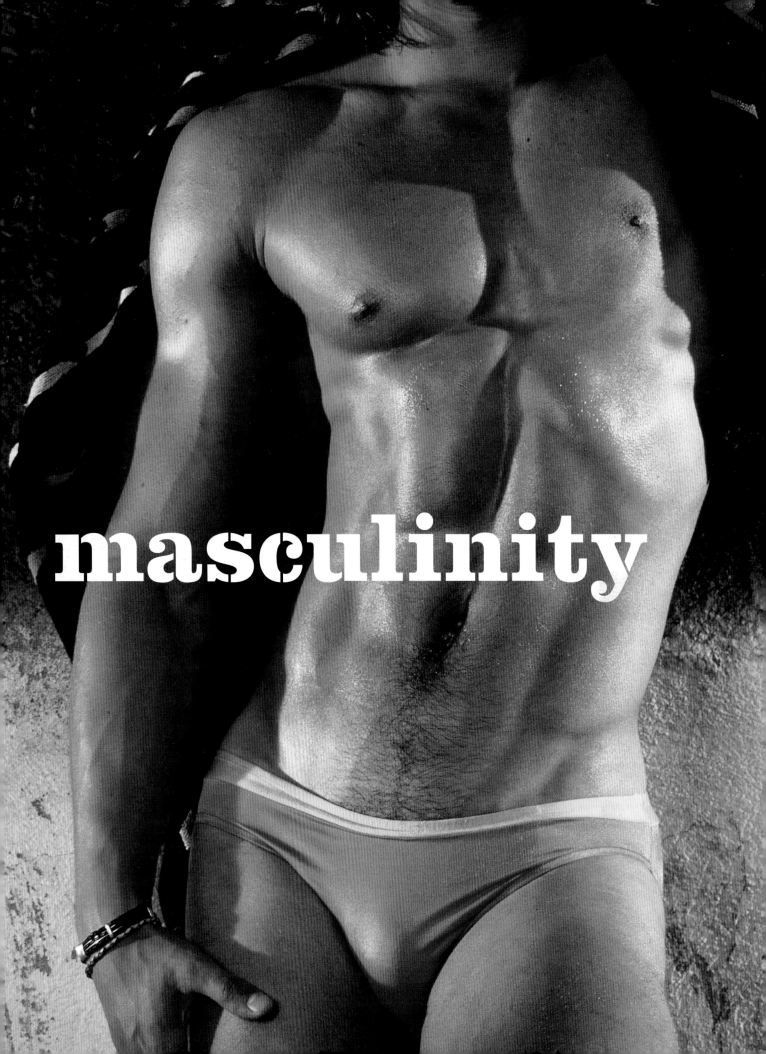

masculinity

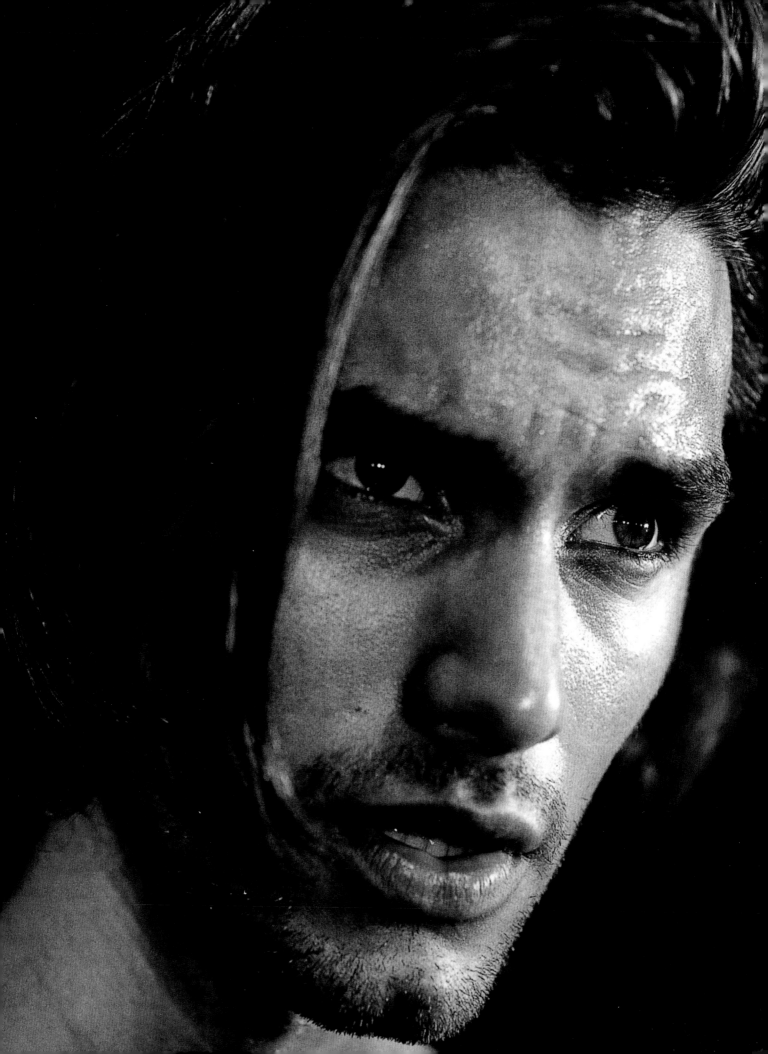

Eve's Elusive Promise

William Norwich

Right
STEVEN MEISEL
New York, 1992

Page 14
KARL LAGERFELD
Paris, 1995

Page 15
PETER BEARD
Miami, 1993
Esquire Gentleman

Among the most rarefied in certain divine circles—those fashionable people who supposedly have the inside track on such things as what really happened in the good Garden of Eden nearly two thousand years ago—it is understood that when the wily serpent tempted Eve he promised her Marcus Schenkenberg.

Instead, all Eve got was history's first fashion: a fig leaf plucked at high cost off-the-karma-rack, but that is another story.

The last time I saw Marcus Schenkenberg was to talk about this book over lunch at a bistro called The Coffee Shop, in downtown Manhattan on Union Square. He arrived with a cap pulled low over his forehead and the collar of his jacket turned up. A loose-fitting native Indian sort of shirt and a roomy pair of dungarees were meant, I suppose, to disguise him. But at six feet four inches tall and with an ivory physique that could marbleize envy even in Michelangelo's *David*, his attempt at disappearing in the crowd was hopeless. Marcus is, for all the world, an extraordinarily beautiful man—Eve's elusive promise, if you will, and some Adams' also, one trusts. He cut—as romantics said of leading men in that other Eden, Hollywood in the 1920s—quite a swath. Heads turned faster than flapjacks flip: Marcus Schenkenberg was in the house.

The first impression he makes is of this man-child, as if the panoramic masculine figure you see trying to pass unnoticed actually is the Olympian body of the superb giant who inhabited an innocent young boy as he was rollerskating on that perfect, bananafish day in Venice Beach, the day a photographer first thought Marcus might make it as a model. Maybe you'd feel this way: transported beyond the humdrum, as if you are sojourning in the jungle and come face-to-face with a king lion whose mane is more finely golden than the rays of the morning sun. Or if a peacock stops in its path for you and spreads its rainbow feathers against the black, windless midnight . . . you would have to know that you are in the presence of a rare creature. (Remember, don't pet the animals.)

Am I fawning?

Oh, well, I was impressed by the specimen, but I could also feel dwarfed, like some old uncle when an Ivy League nephew consents to a sprawling Sunday afternoon chat. Marcus Schenkenberg is at least sixteen times bigger than me in every direction, I'm sure. He slid across the vinyl settee and ordered some sort of grilled Cajun chicken sandwich concoction and mineral water "free," meaning without bubbles or, perhaps, that Marcus is liberated from the impingements and stereotypes mere mortals suffer.

"Are you tired of being called beautiful?" I asked.

Marcus smiled. Shrugged. "You're beautiful, you're beautiful, you're beautiful, baby," he cooed, imitating stylists and photographers he has worked with. "The more you hear it, of course, the less it means. But in the beginning it was very exciting and now, well, it depends on who says it," he laughed.

Beauty, of course, isn't exactly a guy word, at least not until recently. John Wayne, Clark Gable, and even Robert Redford were not called "beautiful." They were handsome. That Marcus Schenkenberg is described by all dispatchers as "beautiful" signifies not just that we the people can finally agree on something,

10

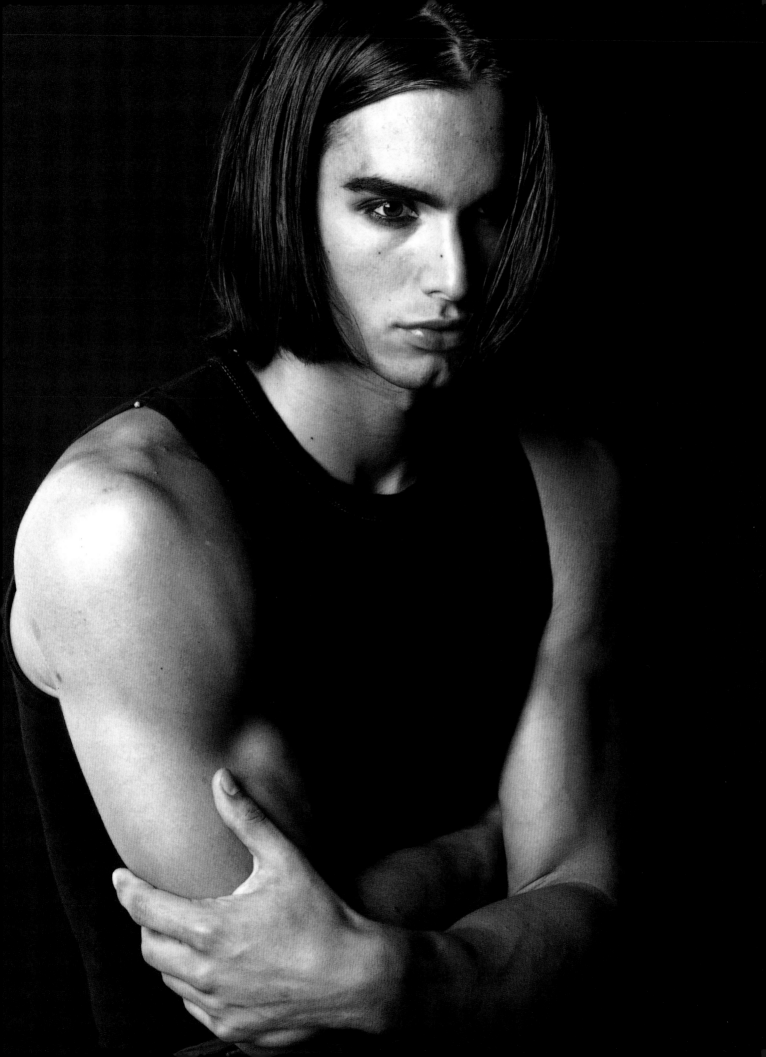

but it tells the story of how the idea of masculinity—its look, its body politics, and its human potential—has evolved. It covers the vain expressions of the Beau Brummel era to now, the era of beefcake. After the Renaissance, it was women, not men, whose flesh was revealed in art. But the advancement of photography has changed all that, especially in the work of physique photographers after World War II. The culmination was the 116-page Calvin Klein advertising supplement for *Vanity Fair* that made Marcus Schenkenberg famous in 1991. Here, with long hair unmanicured by convention, man's hair at a woman's length, and in nearly all his supreme nakedness, was the post-feminist "new male" we'd heard rumors of: this sensitive, Michelangelo-type figure whose Sistine Chapel was the nearest-gym-anywhere-U.S.A. in the century of MTV. These first images of Marcus, making literally and figuratively such a splash, evoked great theatrical boldness; the only curtain to the stage was the fig-leaf–size swatch of soaked denim falling between his thighs.

"Brown is the new black, beige is the new white, and men are the new women."
Jean Godfrey-June

Indeed, the fashion system beamed multiple messages. First, what made these images of Marcus so "fashionable" was the overt expression of anti-fashion, "a kind of transcendent ambivalence," the sociologist Fred Davis has written. "People who look like they're too interested in fashion are not in tune with the times," Calvin Klein explained. Perhaps more interesting to Klein, and his disciples, was the interplay of health and fitness displayed by Marcus. This, not disco smoke and rusty lighting, spells "S-E-X" in the 1990s. It's an interesting twist on modeling that even when he is *not* wearing clothes, Marcus sells fashion. Consider, also, the cover photo of Gianni Versace's book *Men Without Ties*, a photograph taken by Richard Avedon, inspired perhaps by Lois Greenfield's photographs of dancers, particularly of David Parsons. Here we see Marcus leaping free from the confines of ties and suiting, a veritable flag for "Friday wear," the end of officially dictated fashion rules for the otherwise buttoned-up male classes.

"All nudes in art since modern fashion began are wearing the ghosts of absent clothes," Anne Hollander writes in *Seeing Through the Clothes*. Alison Lurie, in her book *The Language of Clothes*, cites the psychologist J. C. Hegel's theory of "shifting erogenous zones," when one or another part of the body—shoulders, stomach, legs, buttocks—is favored by a generation and found exciting. Most recently, Peter Arnell, the advertising wiz, determined the male torso "the sexiest crossover image of the 1990s. It appeals to male, female, young, old." Does a huge chest hold the promise of a generous heart? *New York* magazine calls the phenomenon "pecsploitation"; while in the May 1997 issue of *Elle*, Jean Godfrey-June exclaimed her womanly delight thusly: "Brown is the new black, beige is the new white, and men are the new women. . . . For me, the Bruce Webered Marcus Schenkenberg plastered larger-than-life on a billboard is a sign of having come a very long way."

As Ms. Godfrey-June observed, men are no longer immune to body-conscious self-obsession, eating disorders, low self-esteem, and other questionable joys of keeping up appearances long suffered by women. Captains of industry are rushing into gyms only to realize, to their confoundment, that in these pump palaces, as well as in the most competitive dating fields, it literally is the survival of the fittest—without the pecs, they are low men on the totem pole. *Men's Health* magazine, devoted to such once-only female magazine concerns as fitness, fashion, sex, and grooming, has seen a rise in readership from 200,000 in 1991 to approximately 1.3 million in 1997. Nancy Friday, in her book *The Power of Beauty*, observes that as men face a new century, they are using "their

looks within the power structure of the workplace, they assemble their arsenal—briefcase and great looks too, employing everything to get the contract. . . . We have new rivals in beauty, the very people who were once the prize. Did we honestly think men would let us take their jobs, the role that more than any other defined their masculinity, and not retaliate? And when he invests in the Calvin Klein suit, works out at the gym, and pays for a better barber, he will use the ammunition. No little dance of denial for him."

Marcus politely did not respond when I suggested he will be remembered as the emblem of this sea change in the masculine image. "But I think it's okay for men to become a bit more vain. It's good that they want to care more about their appearance. If women can do it, why not men?"

This is what everyone wanted to know when I told them I'd just had lunch with Marcus Schenkenberg: (1) what does he look like naked, and (2) is he intelligent? Somehow, shortcomings on either front would have soothed those red feelings of envy for someone so seemingly perfect.

In answer to the second most commonly asked question about Marcus Schenkenberg, I can report only by grandly paraphrasing Voltaire: those who think themselves wise are the greatest fools. Therefore, Marcus Schenkenberg possesses the greatest intellectual gift imaginable: the good grace to know when he does not know something, also defined as humility. For instance, his brethren, other supermodels, male or female, may be plotting their takeovers of Hollywood, but when I asked Marcus his plans for an acting career, he answered: "Maybe. Slowly. But I'm not ready. I'm not prepared. I wouldn't know how."

What does he want people to know about him?

Marcus paused. "That I do my job. That what you see is what you get. That I'm just a normal, uncomplicated guy. I don't know," he smiled. "Modeling is like entering a lottery. You go, especially in the beginning, to all these castings and *maybe* you get the money job that day. You grow up very fast. You're in a crazy world, and I feel very, very lucky to have survived."

Someone once wrote that Marcus Schenkenberg has the face of an angel and the body of a Chippendale's dancer. A nicer way of putting it would have been to illuminate his subtle androgyny, another significant factor in his universal appeal.

But it reminded me when last I'd seen Marcus Schenkenberg before today, in Paris, on the occasion of Alexander McQueen's first couture show for Givenchy in the winter of 1997. In the grand hall of the École des Beaux Arts Marcus was suspended from a balustrade. He wore only cloud-white briefs and his skin was brushed with gold. In 1634 Rembrandt painted a slightly less Adonis-like version of this image and called it *Cupid Blowing a Soap Bubble.* Behind Marcus was an expanse of feathery angel wings at least twenty feet in plucky diameter. The show was late to begin, something like two and a half hours. It was a cold day in January in the marble hall, even for an eighteen-karat angel paid a heavenly fee. Lucky for him, because he was exhausted with jet lag, he was strapped to a protective harness. Long into his third hour hovering above a pack of been-there-done-that international fashionistas, he admitted, "The angel was getting a little pissed off."

But it wasn't the worst job he ever had. That was a few years ago at an awards ceremony televised from Ibiza. As master of ceremonies, Marcus's first order of business was alighting from a horse before a live audience and delivering his lines on cue. Well, suffice it to say, the stallion was no angel.

The beast had other ideas, or needs, as the French might say.

> ## ". . . it's okay for men to become a bit more vain. . . . If women can do it, why not men?"
> **Marcus Schenkenberg**

13

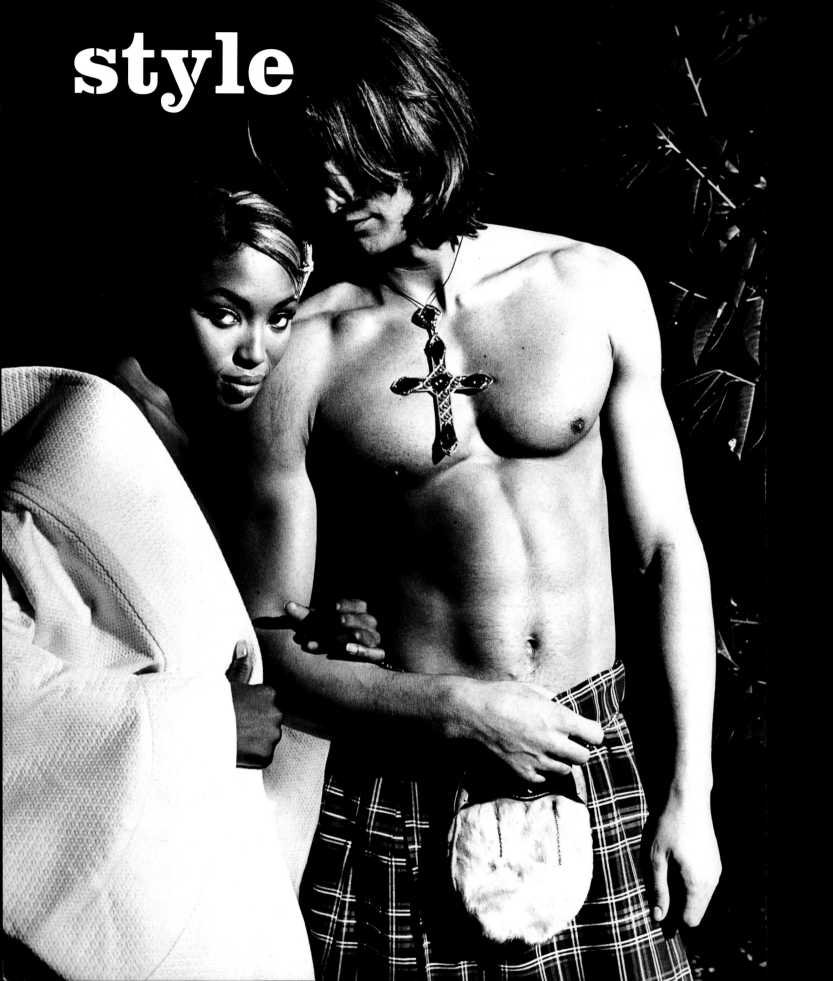

style

sex

A Book
Marcus Schenkenberg

When my agent, Jason Kanner, asked me if I wanted to do a book, my first thought was, *a book*? That's something you do *after* your career's over, or even towards the end of your life when you can include your memoirs. But then I thought, hey, no other man in my profession has ever done this, and I'm right in the middle of a huge change in the way people view male models, men's fashion, style, beauty—men in general. It's an exciting time that should be documented.

So I'm sitting down now to write the intro to my book. . . . I must say, it hasn't been easy to meet with everyone, collect material, and write while traveling the world working at the same time. But it was worth it, since I've been fortunate enough to work with the world's best photographers, designers, stylists, and hair and makeup people in the industry—and who better to fill us in on what's happening in men's fashion?

I also thought that doing this book could open more doors for other guys in my profession by making more people aware of men's fashion and by showing new and different images and looks. Already the interest and the publicity has exploded; even the term *male supermodel* didn't exist a few years ago.

I want to thank my family, Jason Kanner, my friends, and everybody who has believed in and supported me throughout my career. I'm also very happy to be able to donate proceeds from sales of this book to a foundation dedicated to finding a cure for multiple sclerosis, since that affliction has had a personal affect on my life.

Love, Marcus

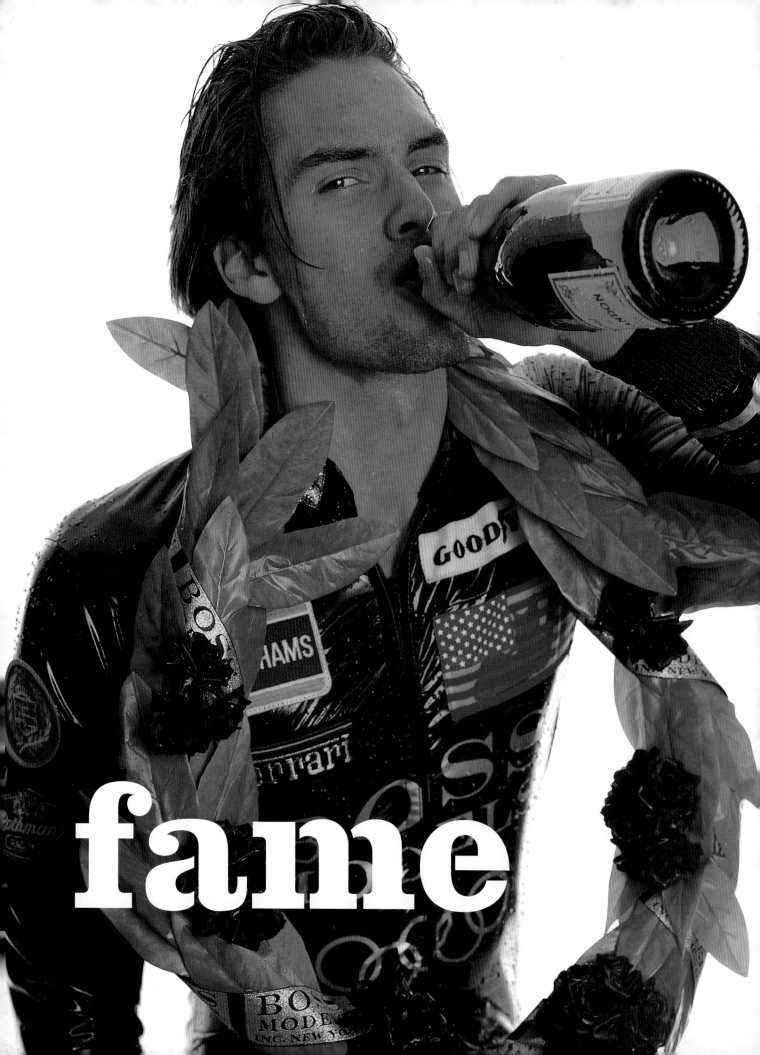

fame

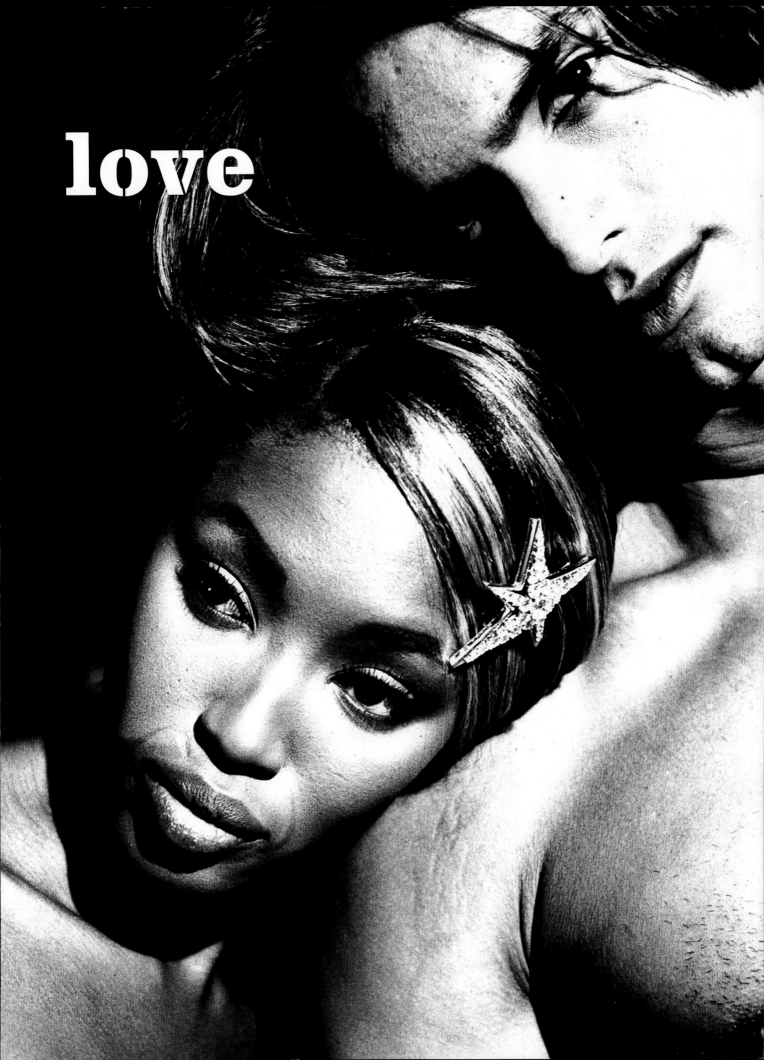

love

Ciao, Stockholm!

one

21

Still the Sweetest Cat
Yvonne Schenkenberg

They said it was going to be a girl, so I had already made a dress during my pregnancy. And when it happened, it all happened very fast: "plop" and out came a little boy of eight pounds. He was really cute, with long, dark hair, a copy of his brother who was born two years earlier. Today, they don't look that much alike: Michael became blonder while Marcus retained his dark features. My initial disappointment quickly changed to happiness; we now had two wonderful boys and they always were, and still are, the best of friends.

Growing up, Marcus was pretty much trouble-free. He was always a shy and sensitive boy. He loved animals and we always had cats and sometimes kittens for him to play and cuddle with. One of our cats—the one Marcus chose when he was twelve—is, today, sixteen years old. But the sweetest and most special cat in my opinion is, of course, Marcus.

Whatever he did in sports he did well: skiing, badminton, and tennis. But basketball became his big passion. Marcus started playing at the age of nine, when his brother was already playing. Michael got tired of it after a couple of years,

but Marcus started playing in age groups older than his own and later transferred to Solna, the best junior team in the country, even though he had to travel one and a half hours, four times a week after school to get to practice.

At age fourteen, he bought a moped with his savings. Two years later, he sold it for a profit, bought a motorcycle instead, and I was thinking, "What a business man he's gonna be. . . ." A music teacher in school thought Marcus had musical talent and talked him into playing the violin. He got sick of that pretty fast (we did too).

During summer breaks he worked at the Stockholm amusement park to save money for a trip to the United States with one of his best friends—very much like his father and I did when we were young, and left Holland for Sweden. The rest of the story everybody pretty much knows. Despite his success, he's still the same considerate, nice, sweet, and generous boy, and we're very proud of him.

Love, Mom

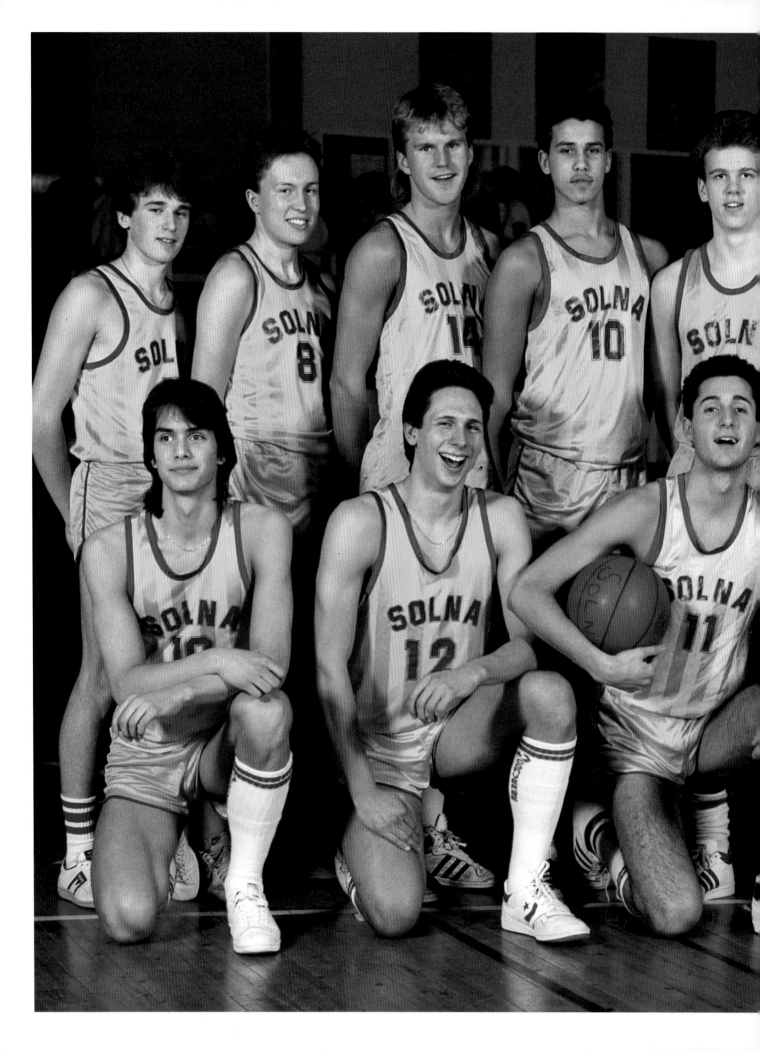

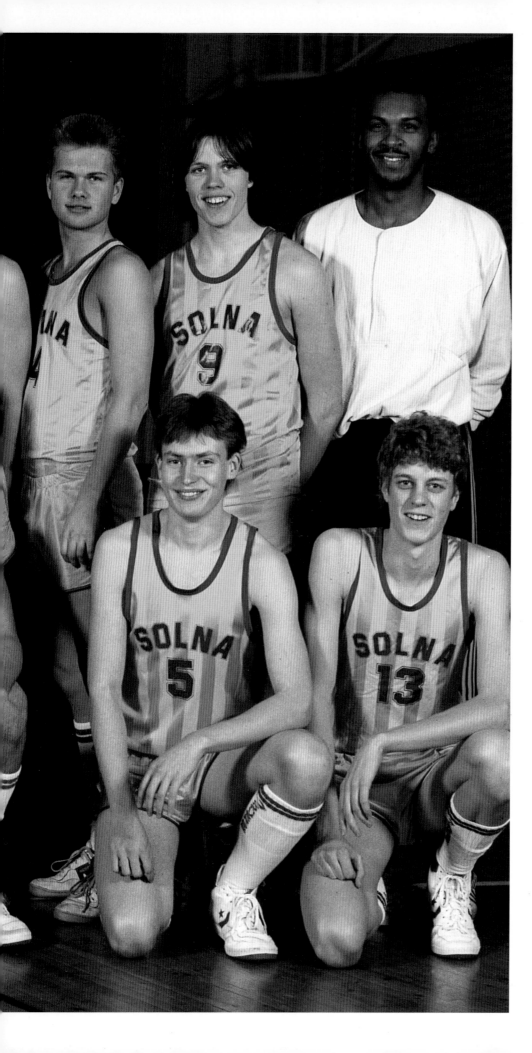

Solna basketball team
Sweden, 1986
Marcus (first row, left)

Pages 22–23
Clockwise from top:
Mom, 1971; Mom, 1971;
Mom and Dad, 1975;
Two weeks old, 1968;
Stockholm, 1969;
Mom, 1968; Michael,
Jessica, and Smulam,
1978; First steps, 1969

25

He Ain't Heavy...
Michael Schenkenberg

This Page
Marcus and Michael
Stockholm, 1978

Right
Michael and Marcus
Stockholm, 1975

My overall memories of my little brother, Marcus, are that he was a very quiet kid and sort of shy. He was extremely kind and felt great concern for every living thing. I think that was one of the reasons that Marcus and I very seldom fought. Though we were not always friends, we almost never had an actual brawl and seldom even screamed at each other. I also cared very much for him and, if it was ever the case that he was hurt somehow, I never hesitated to rush to help him. We had a mutual respect for each other in spite of, or maybe because of, the fact that we were very different. Marcus is hard to characterize as a youngster. He was a cool guy who didn't feel the need to get attention or prove himself in any way (and look what became of him). I remember that I sometimes got jealous because he always seemed to be pleased with everything. It often happened that when he started playing with something, I would want to play with it as well, and would try to convince him to play with something else. It always looked more fun when he had it. Then, when we got older, we had such different ways of living that our paths rarely crossed. I do remember that he liked motorcycles and cars, while I didn't. I also remember being surprised when he suddenly decided to travel to the U.S. to "collect some new experiences." Most Swedish kids who take off to the U.S. do it in some kind of organized way. Marcus just left. I knew then that he was not just a kid with self-control and character, but he also had an ability to take initiative and the guts to take daring leaps.

Kram, Micke

26

Mission

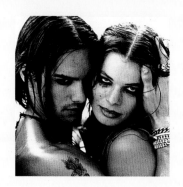

U.S.A.

When I was a little boy, the U.S. was what I saw on TV—this big, wild, crazy, violent place. *So* exciting. I remember one of my friends in school saying, "If you go to the U.S., there are only two choices of things to do for a living: be a cop or a criminal." Ironically enough, as I'm writing this right now, there's a special news story on TV about a sixty-nine-year-old man who opened fire on the top of the Empire State Building, shooting six strangers, including tourists, of course, and then turning the gun on himself. These kinds of things I would read about and see on TV in Sweden; America seemed so far away from my world. I think these images could make any foreign teenager a little paranoid and apprehensive.

When I was an early teenager, I realized that this wasn't the truth but I still had no idea what America would really be like. So, when I was seventeen, I decided I wanted to see for myself. My best friend, Anders, and I saved our money and after a year we were ready for our trip. My mom was very nervous, as was our cat, Lillian, who ran around the house like a freak. Our flight took off on January 3, 1988. . . .

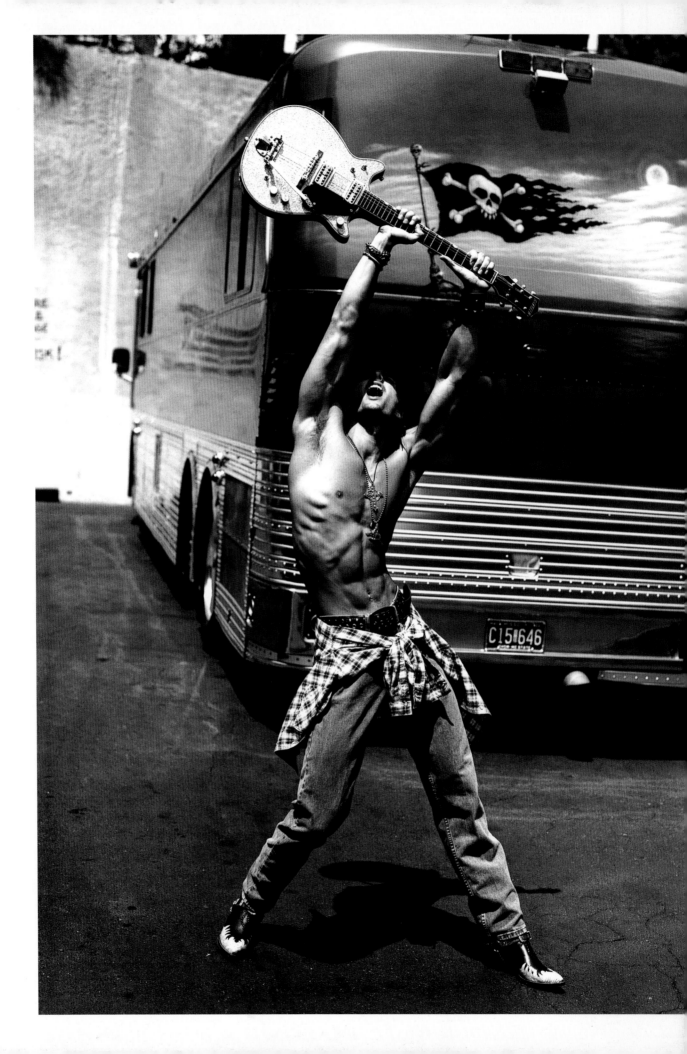

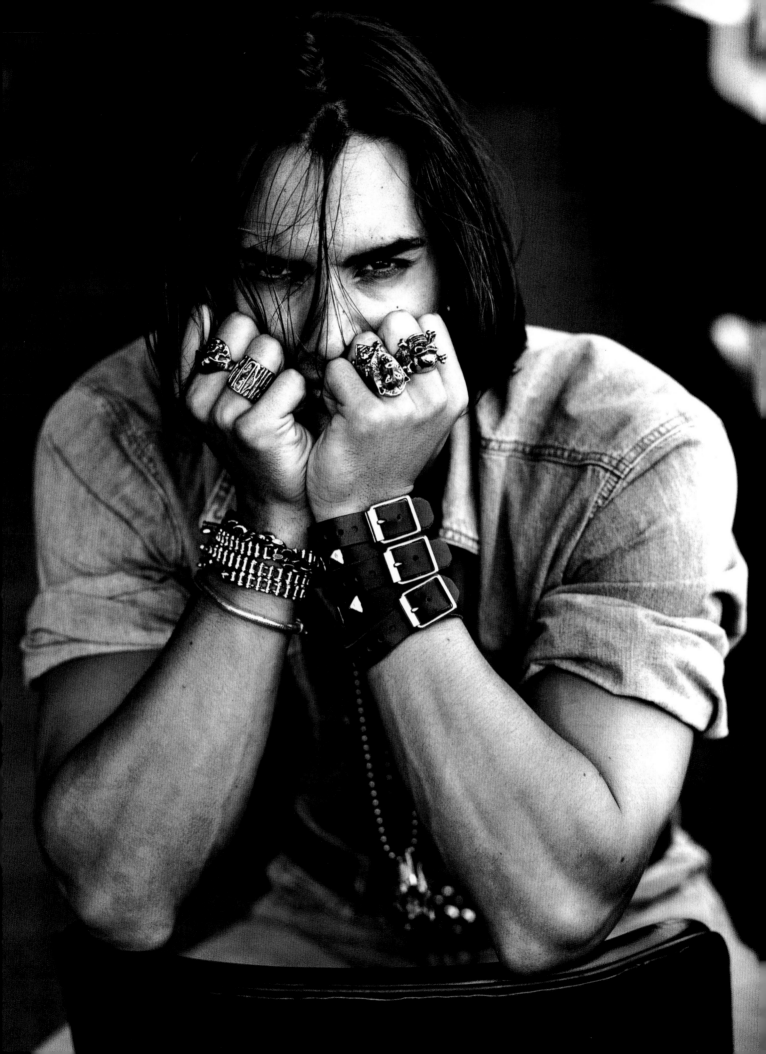

Pages 28–33
ROBERTO DUTESCO
Los Angeles, 1992
Hollywood Jeans
campaign

Falling to Earth

tokyo

35

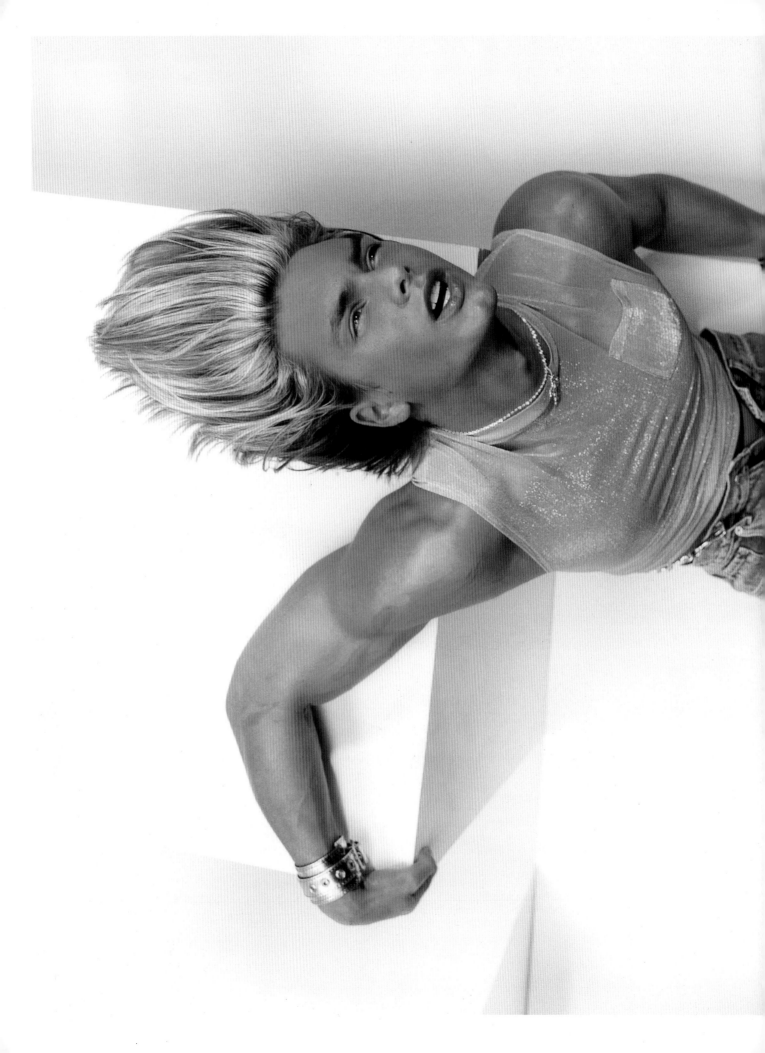

DAVID LACHAPELLE
New York, 1995
Details

37

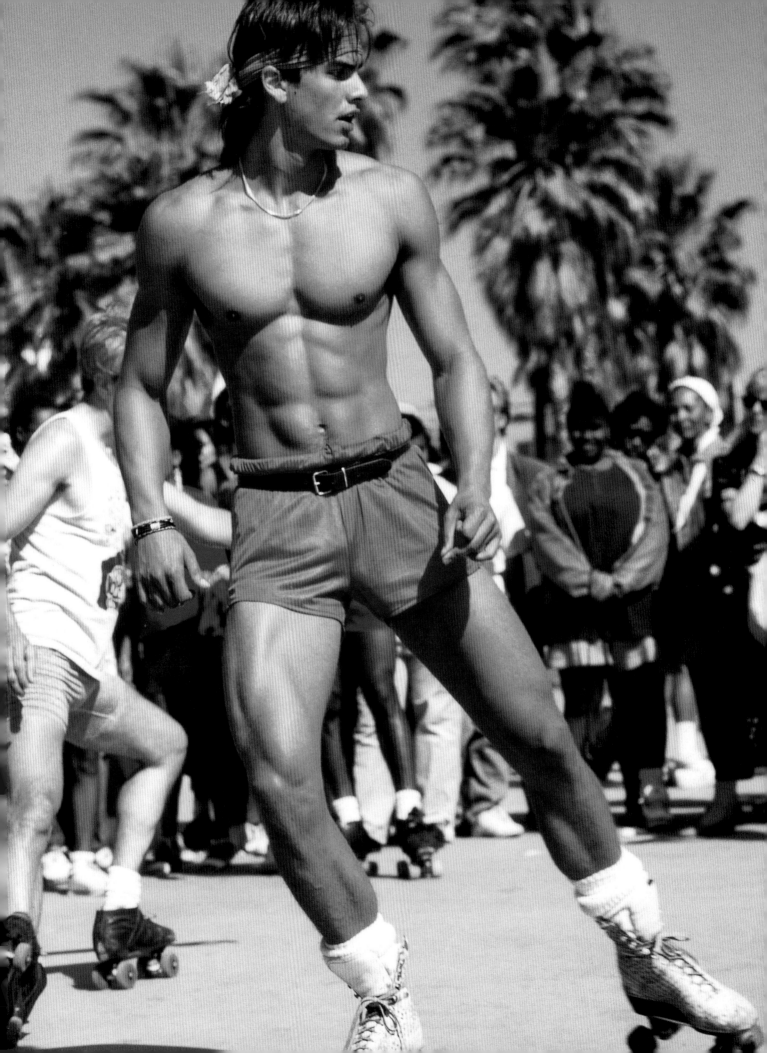

discovered

Left
BARRY KING
Los Angeles, 1989

When I first came to the U.S., I decided to live in Los Angeles. It was so sunny and warm and there was the beach—it was like a different planet from Stockholm. I took a job taking care of seven dogs for an old man in Beverly Hills. I worked with the dogs for six months, until I got fired because one of the little dogs scratched its neck trying to jump a fence, and the owner blamed me. I got a new job with a family, to take care of their two kids and live in their guestroom. I wasn't too crazy about cooking and cleaning, but it was a good experience. On the weekends I went to Venice Beach and was fascinated by a group of roller-skaters that met there every weekend. They did amazing routines and tricks. I was watching them one day, when one of them asked me to try it. I said, "I'd never be able to do that!" They convinced me that it was easy to learn, so I rented a pair of skates, and they took me off to the side to teach me. It was such a blast that I went right out and bought a pair of cheap secondhand skates–all I could really afford–and went back every weekend until I started to get pretty good. I also practiced around the swimming pool of the house I stayed at. Since my skates were so bad, I'd take the wheels off the little 9-year-old girl's skates who lived there. (She had the best skates and never used them, anyway.) When I realized what a huge difference the better wheels made, I saved my money and bought a pair of high-tech skates of my own. It didn't take that long for me to become one of the better skaters on the beach. After about six months, I was there doing a routine with my friend Issa, when this guy approached with pictures he had taken of me the weekend before. I didn't even know he had taken them. He told me his name was Barry King and that he was a photographer. He said I should model, and offered to take some test shots for me and help me look for an agency...

adapting: With Barry's help, I was signed up at an agency and did some small jobs right away. My first shoot was for a poster. I couldn't believe it. I wrote all my friends in Sweden that for one afternoon, barely working at all, I made $500! About a month later, the agency sent me to Europe.

TYEN
Paris, 1990

Pages 42–43
CARLO BOSCO
Stockholm, 1994

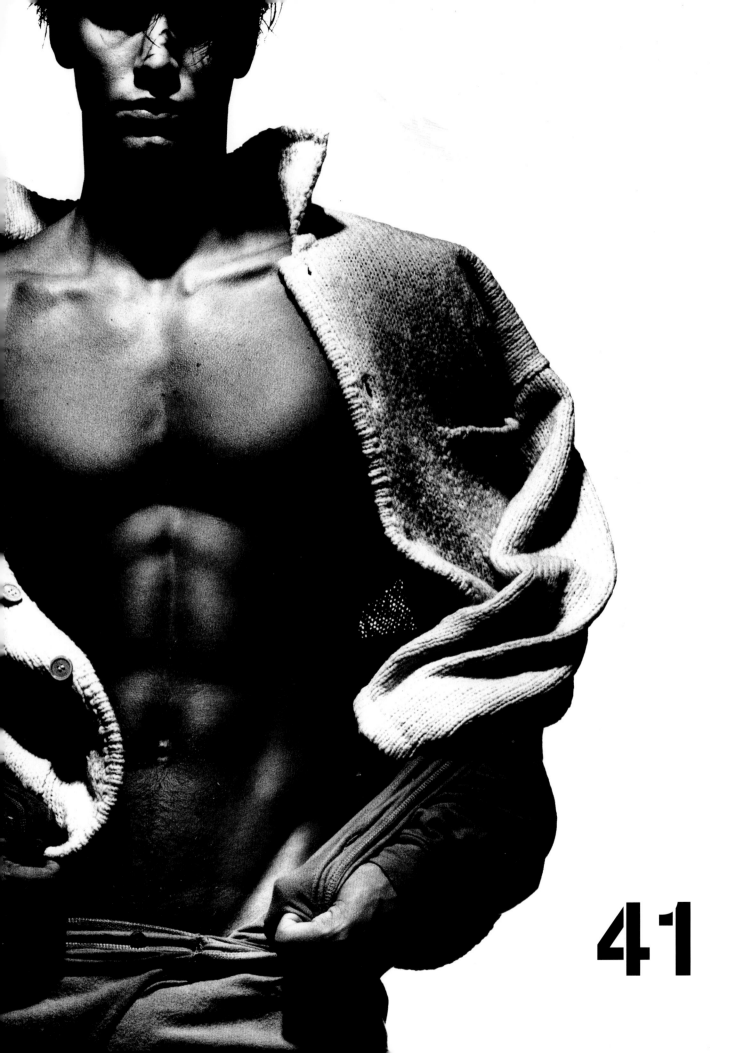

41

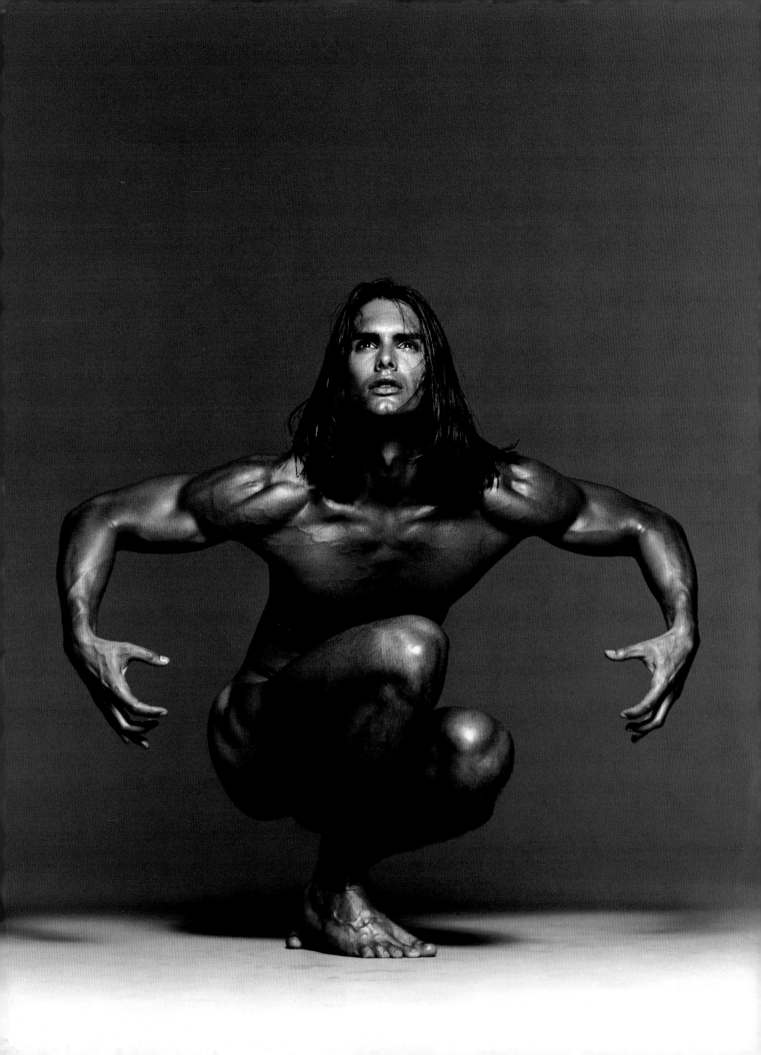

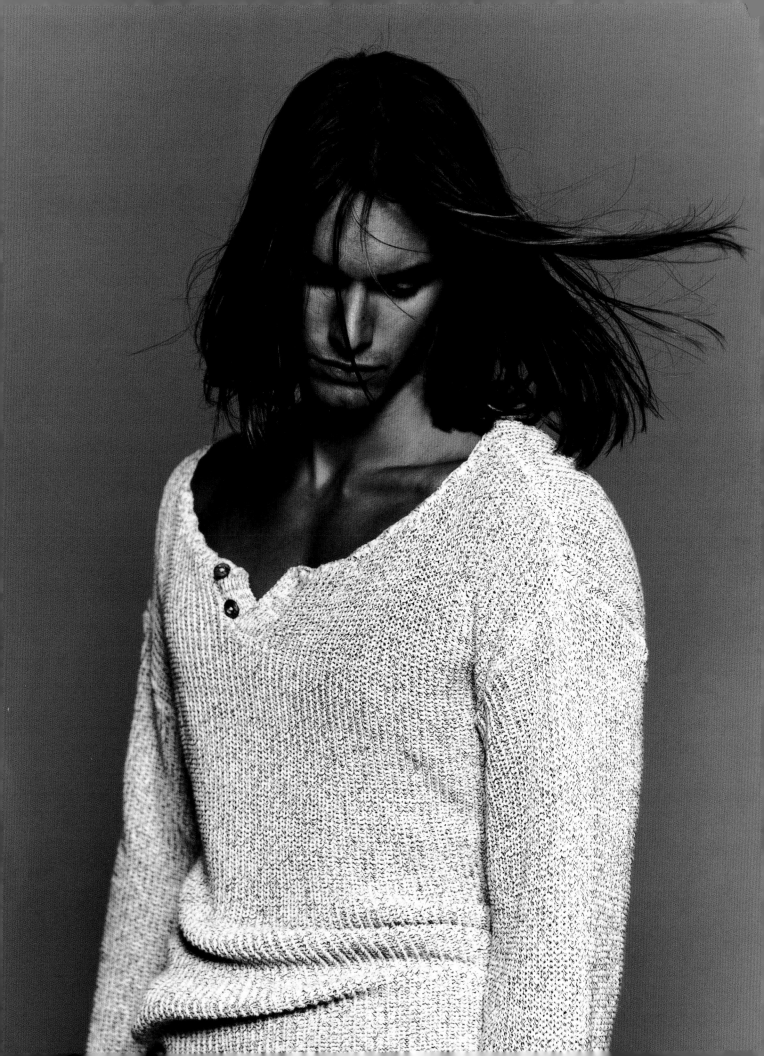

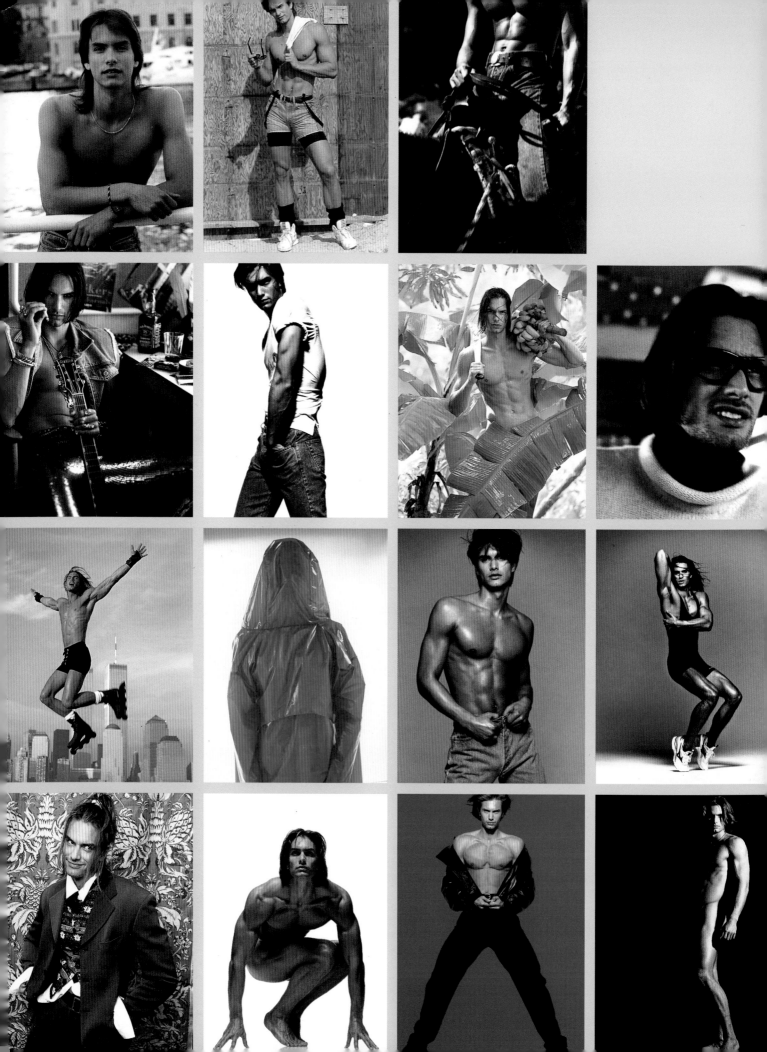

(r)evolution

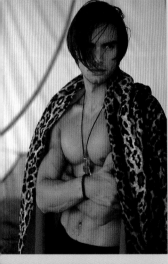

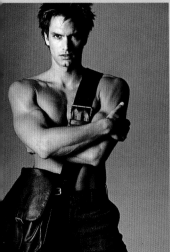

1st Row left to right
KARY H. LASH
Stockholm, 1989

KAL YEE
Los Angeles, 1989

BERSA
Mexico, 1992
Marco Polo Jeans

2nd Row left to right
ROBERTO DUTESCO
Los Angeles, 1992
Hollywood Jeans

TYEN
Paris, 1989
Ferre Jeans

MARCO GLAVIANO
St. Barth's, 1993

STEPHANIE
PFRIENDER
New York, 1993
Uomo Harper's Bazaar

3rd Row left to right
MARCO GLAVIANO
New York, 1994
Calendar

PATRIK ANDERSSON
New York, 1997

TYEN
Paris, 1990

CARLO BOSCO
Stockholm, 1994

THOM GILBERT
New York, 1992
Vogue UK

4th Row left to right
GUZMAN
New York, 1994
Details

CONRAD GODLY
New York, 1995

MARCO GLAVIANO
Milan, 1994
Verri Jeans

ALBERT WATSON
New York, 1997

MICHAEL TAMMARO
New York, 1996

RANDALL MESDON
New York, 1997

45

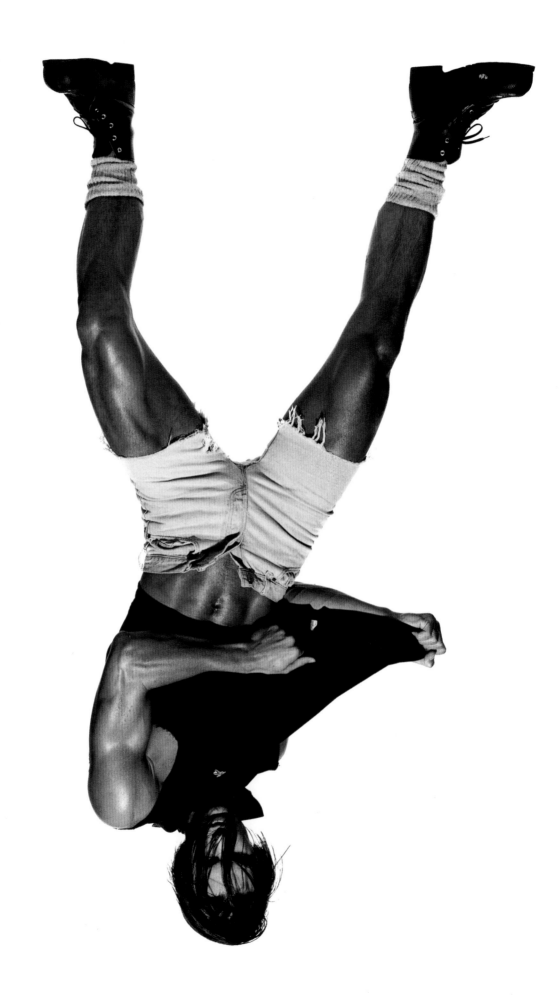

CARLO BOSCO
Sweden, 1990

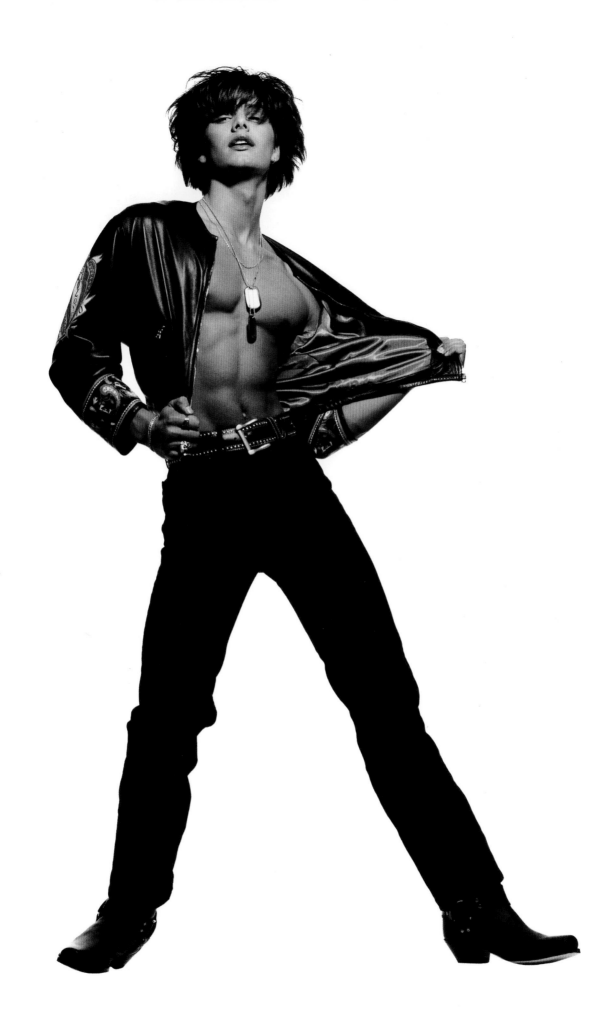

Calvin Klein campaign, San Francisco: Bruce Weber told me, "You're not going to actually wear the pants, Marcus. Maybe you'll take them off and cover yourself." I told him, "It's fine as long as I don't have to *show anything*, you know." For Europe it's not a big deal, but I guess for America it was pretty wild.

put
to
the
test

48

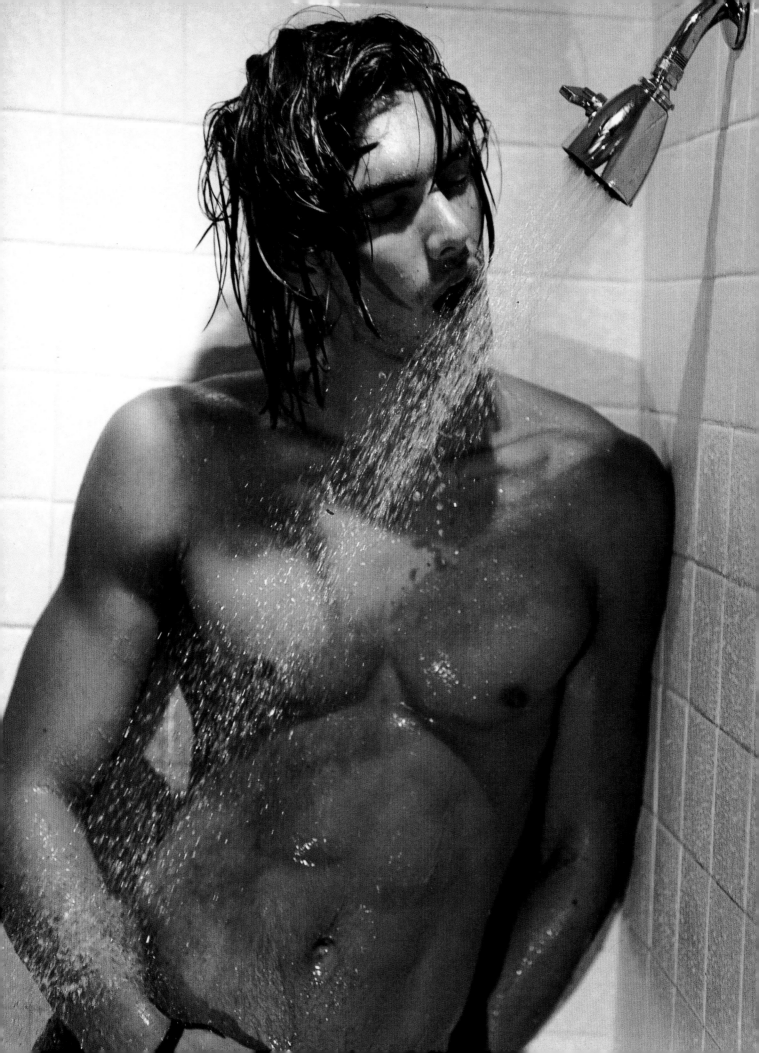

51

Pages 49–54
BRUCE WEBER
San Francisco, 1991
Calvin Klein campaign

52

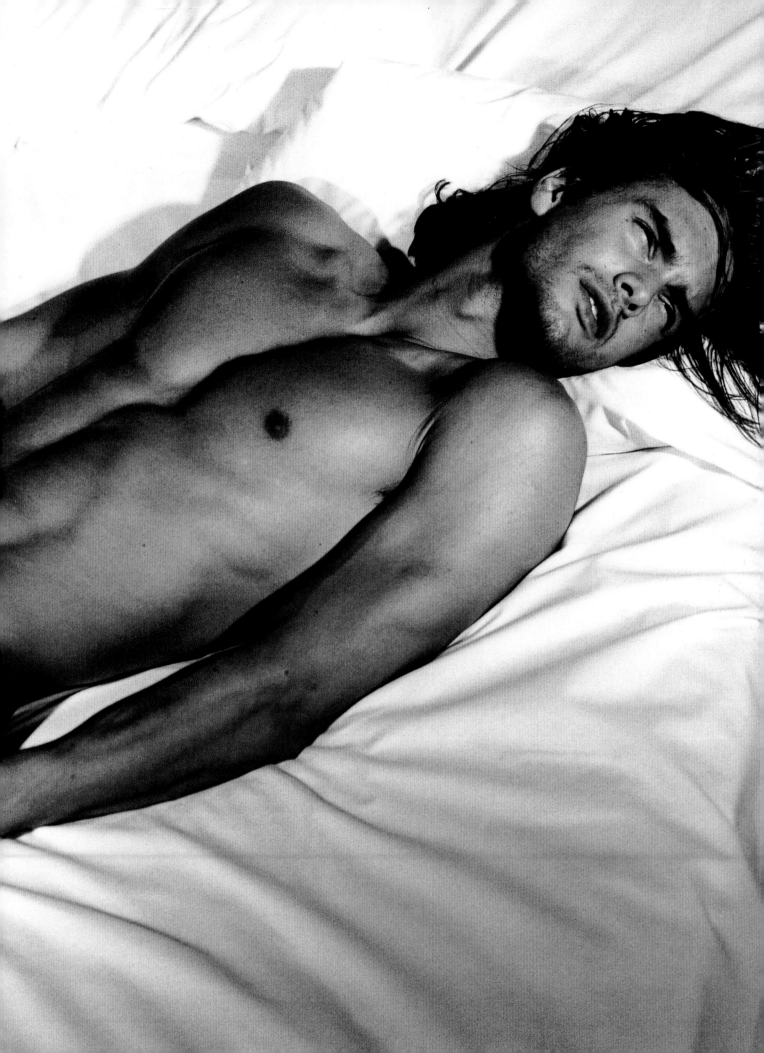

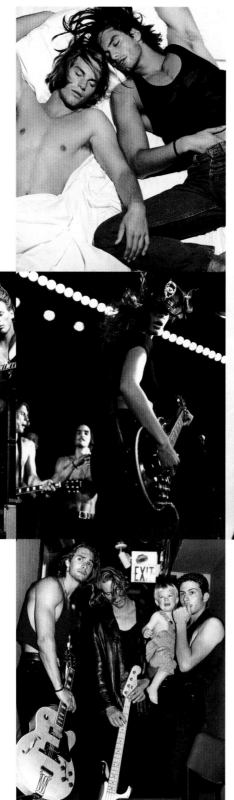
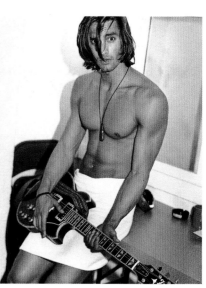

54

04.20.1991

Woke up early today. Excited about finally being confirmed to go to San Francisco for the Calvin Klein campaign! Flew on the 12:00pm flight from Paris to New York. Watched "Ghost" on the plane. Called Maureen when I got to New York. Haven't seen her for two weeks, and now I'm finally in New York but have no time to see her! Frustrating! Oh well, one more week. Flew to San Francisco—six hours. Couldn't sleep–dead tired though. Taxi to Huntington Hotel. Haven't slept for twenty-four hours. Went straight to bed.

04.21.1991

Woke up very early. Called Maureen in New York. Breakfast by myself. Meeting at 9:30am with Bruce Weber and the others (assistants, stylist, makeup and hair people, etc.). They must have been setting this up for a week. Very elaborate set. Bruce told me I needed a tan and a haircut, and explained what the shoot was going to entail. Then I tried on jeans, t-shirts, etc; trimmed my hair; went straight to the tanning booth. Have the rest of the day off. Shooting starts tomorrow. Went shopping, played basketball with two of Bruce's assistants. Went out for Chinese food with one of the other models, Eric, from Santa Barbara.

04.26.1991

Took five days to do all of the Rock n' Roll shooting. Bruce chose four models, Carré Otis, and me to be the band members, and then there were fifty to sixty models cast as extras to play the press and audience. Bruce set us up on stage, and we played air guitar and screamed. Bruce would run around everywhere shooting. We all had fun, and I was surprised to find out later that Bruce decided to focus on Carré and me. I didn't even know who she was until Eric explained to me during one break that she was a famous model and was dating Mickey Rourke. I thought she was just another new model like the rest of us since that's the way Bruce usually likes to work. She didn't really mingle with anyone, though, and was very quiet. During breaks she was always off with some guy who watched the shoot everyday. Eric told me later that he was Mickey's brother, who was there to keep an eye on her.

04.06.1992

Didn't sleep very well. Went downtown Manhattan to do an outside location shooting for *Harper's Bazaar* with a new British model on her first U.S. booking, Kate Moss—a quiet, skinny girl with a funny South London accent. She had on leather pants kept together with pins that looked like they were going to fall off. Was fun at first, but took forever. Photographer shot a zillion rolls on every picture.

Brave New York World

three

57

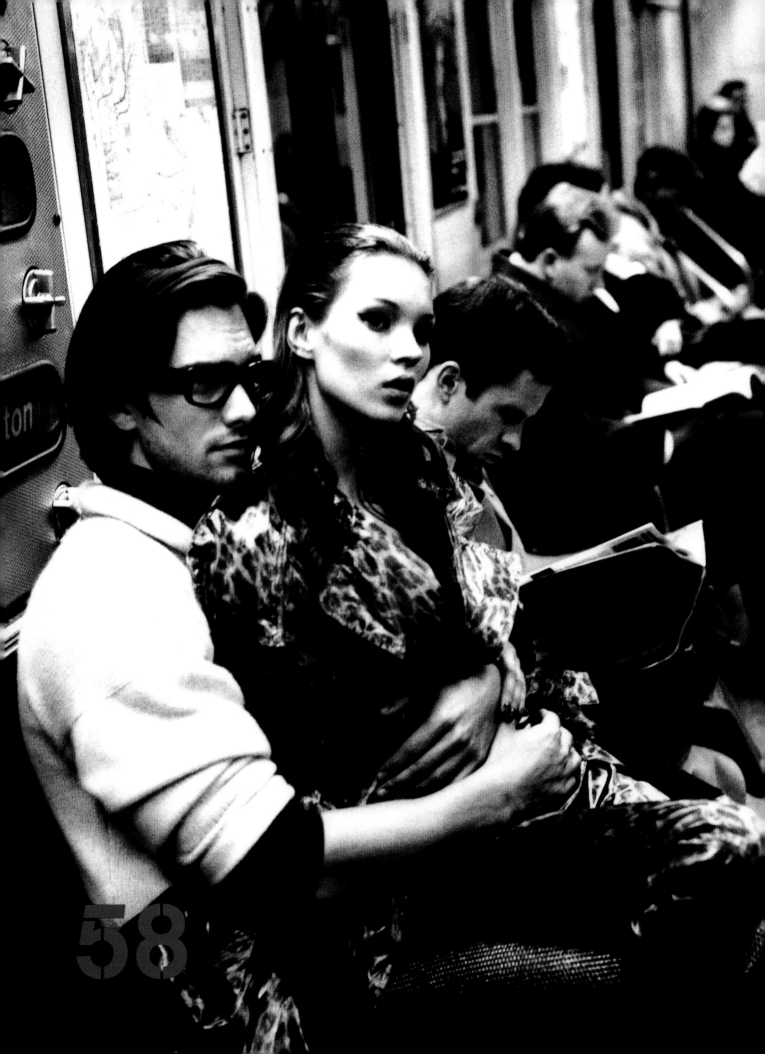

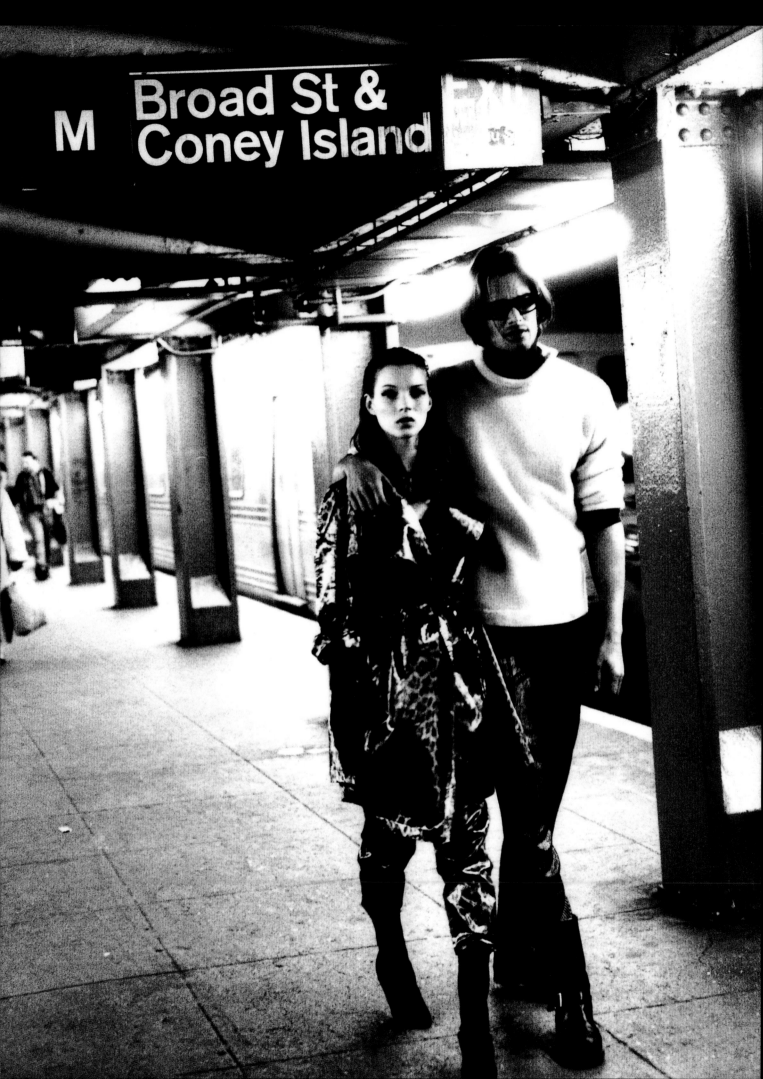

Gotham Confidential

Pages 58–64
STEPHANIE PFRIENDER
New York, 1993
Uomo Harper's Bazaar

Later, in 1991, I came back to New York as a model. I had actually been living in Paris when I met this wonderful girl, Maureen Gallagher, who I started seeing. She lived between New York and Paris. I had just been hired to do the Calvin Klein campaign with Bruce Weber shooting in San Francisco, so on the way back to Paris, I decided to get off the plane in New York and move in with her. We were crazy for each other

After about a week of making love, I started to get a little restless. Since I had nothing to do during the days, I decided to look for an agency. I went around to Wilhelmina, Ice, Men, and Boss (again) and was met with a completely different response than the rejections I received the first time I tried. Since I had already started working, I had some good tearsheets, some experience behind me, and a much more buffed body as well. In the end, I decided to go with Boss, a smaller agency, but one that seemed very excited about representing me (and they didn't have any objections to my long hair). Maureen and I moved into a bigger apartment on 57th Street, between 8th and 9th Avenues—perfect because we were just around the corner from Central Park, which we always took advantage of, especially in the summertime. It's still one of my favorite spots to visit on the weekends in New York, to relax and hang out with my friends in Sheep's Meadow.

I've now been based in New York for several years. It's really impossible to become bored here. I have my own apartment and have made it *reeeaal* nice and comfortable, so I always look forward to coming back. There's also the convenience of the delivery services—you really don't ever have to leave your apartment if you don't feel like it, which happens to me quite often when I come back from long trips. The only thing missing in New York is the beach and the sun.

60

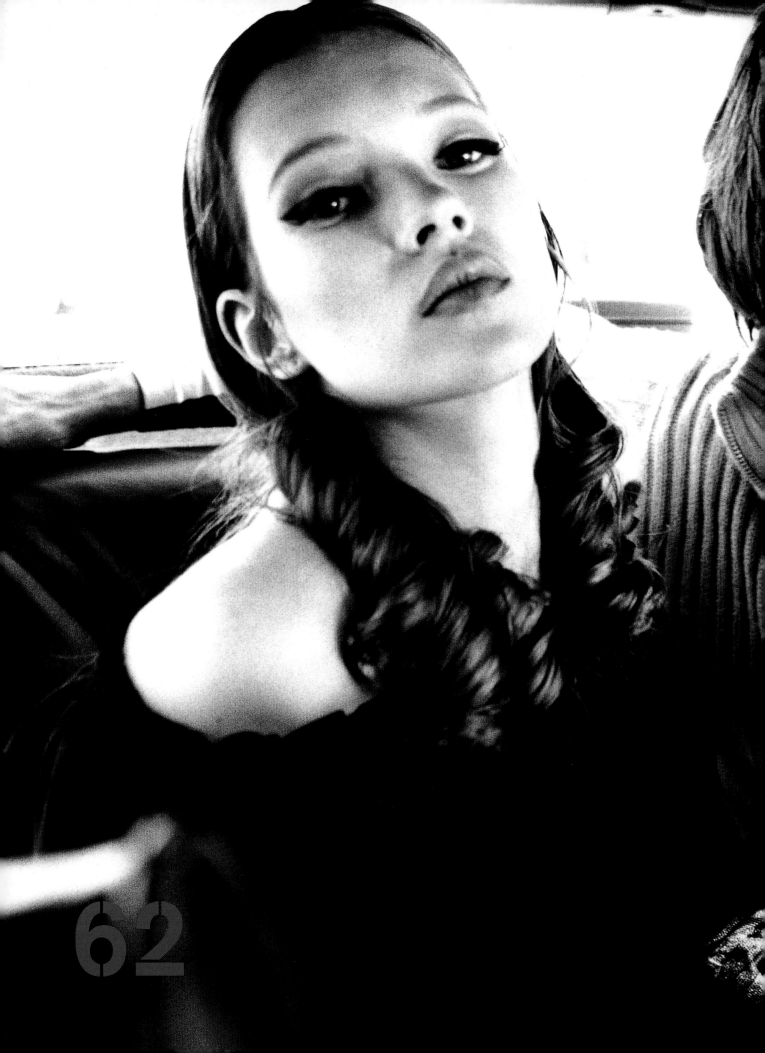

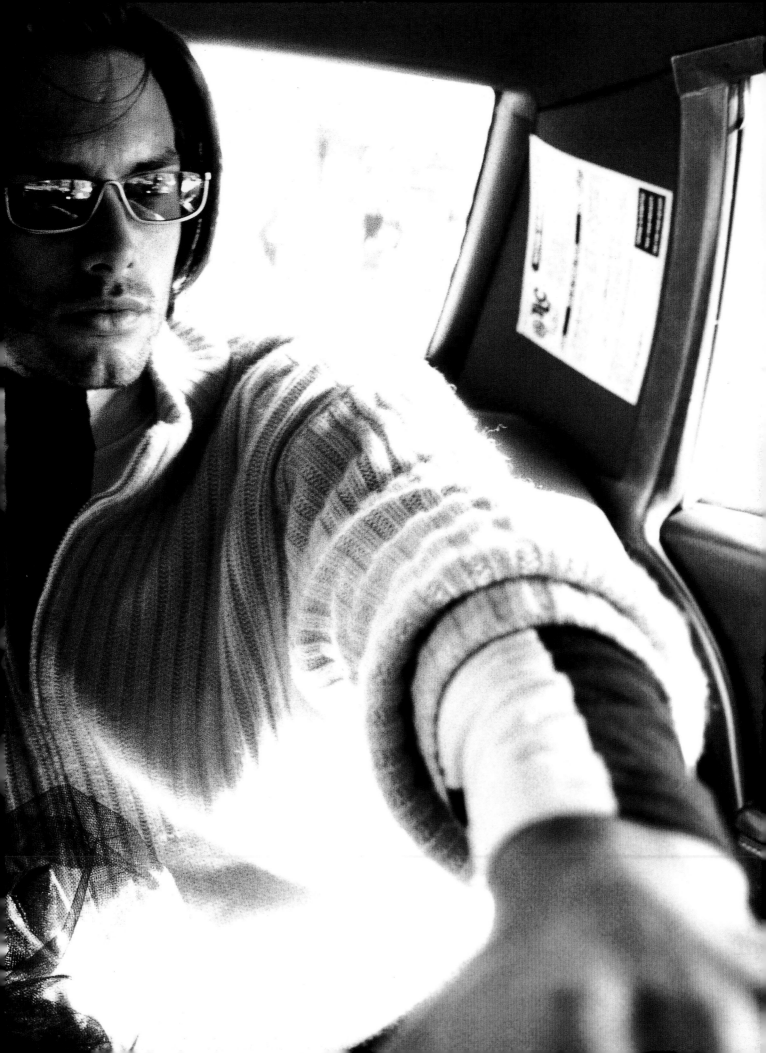

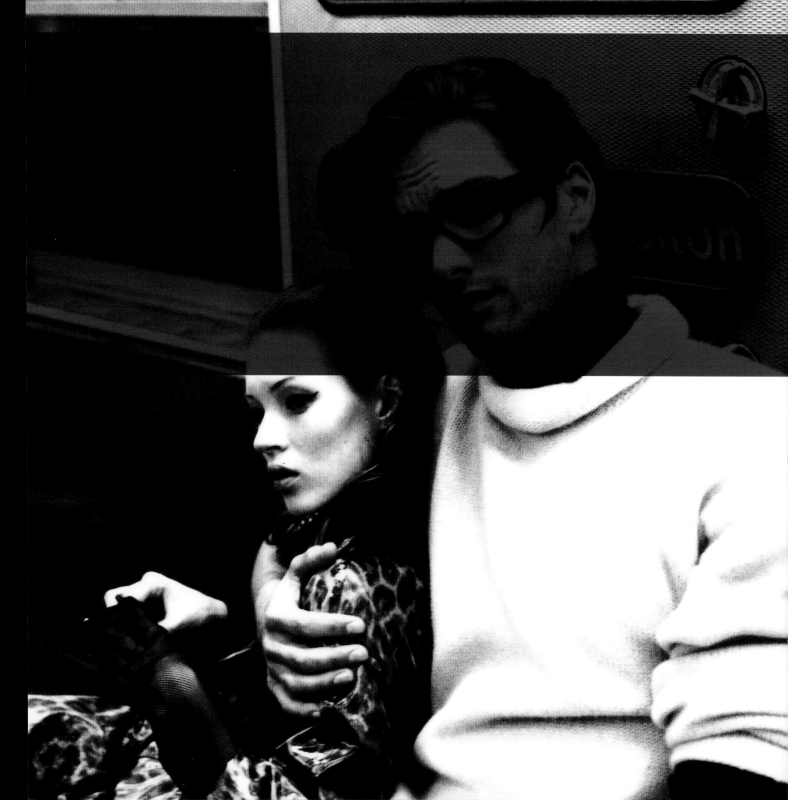

Book 'im

In the beginning, booking Marcus was never an easy task. At the time, there were no male models that people knew by name, and the only jobs available were very small, underpaid advertising campaigns and lackluster editorial beefcake work. When I first met Marcus, I saw immediately that he had the potential to be a huge success. But trying to convince the rest of the industry was something else altogether. Given the challenge, I had to approach every opportunity (photographers, editors, and art buyers all included) as if it was a civilized war—bombarding them with photos and ideas, trying to open their minds to the concept of a male fashion icon, a supermodel. Most people didn't get it, and they didn't get him. He was really tall (a little under 6'3"), had very long hair (which no one had at the time), and this incredible body that intimidated a lot of people.

It was the heretical few who took the risk and made Marcus . . . *Marcus*. These few, the only people in the industry who always took major risks in their work, slowly began to book Marcus and to shape his image.

I remember one of Marcus's first supporters, Joseph Oppedisano, the editor of *DNR (Daily News Record)*, the biggest trade magazine for men's fashion, got it right away. Marcus's Calvin Klein ads had just debuted, and there was a huge media buzz surrounding him. Joseph, eager to capitalize on the hype, wanted Marcus to do a *DNR* cover sitting, modeling designs by the then-brand-new designer, John Bartlett. Not only was it one of Marcus's first bookings, but it was also *DNR*'s first glossy-cover issue.

But I wasn't satisfied with a mere first-time cover placement. I wanted his name printed on the cover as well and just as big as John Bartlett's. Needless to say, those at Fairchild Publications were at a loss. "No one cares about the model," they told me. "It doesn't matter if his name is on the cover or not." Persisting, I told them that there'd be no Marcus on the cover without the credit. At first I worried that I was putting too much emphasis on a relatively minor issue but somehow I knew that my instincts were right on this one. Finally, through major prodding by Joseph, the designer, and of course the agent, yours truly, the shoot went off without a hitch. When the issue came out, Marcus was on the cover, his name was just as big as John Bartlett's, and the entire industry took notice. I felt so proud. I didn't realize until then what kind of feat had been accomplished. Fairchild Publications had never done that before—not even with their women's publications—and they've never done it since. It was a major victory that spurred on many more victories for Marcus, and now countless other male models have benefited from that breakthrough. The rest is history.

Jason Kanner, Booking Agent

65

extra! Marcus Schenkenberg was the first male model ever to become a household name. This is remarkable for two reasons: (1) the concept of male model-as-celebrity at the time had never been considered, and (2) the name "Schenkenberg" is as hard to pronounce as it is to write. Not the usual fodder for the household-name kingdom. Nonetheless, his attractiveness, sensuality, and bigger-than-life personality destined him to a career that would be both personally successful and groundbreaking for the men's fashion industry. With a physique dually appealing to women and inspiring to men, an actor's focus and willingness to experiment during photo shoots, Marcus was able to push the limits set previously in the male modeling industry. Trish Becker

down time

Clockwise from top:
Italy, 1995; Times
Square, New York, 1994;
Lake Rudolf, Kenya,
1993; Patricia
Velasquez, Arizona,
1994; Jean Beauvoir,
Key West, 1995; Angie
Everhart, Kenya, 1993;
Airport, 1995 (Patrick
McMullan); Cameron &
photo assistant,
Seychelles, 1994

I rarely take a vacation. Even my night life seems to revolve around work. But I try to find some time to myself to do things that have nothing to do with my job:

1. Call Mom, of course. We talk at least once a week.

2. Work out.

3. Play basketball. I play pickup at a gym a couple times a week when I'm back in New York. It's still one of my favorite things to do.

4. Play video games. Before we go out—or when we want to stay in—Cameron, Jason Olive, Joel West, and Gregg Spaulding will meet me at my place to play video games on my big screen. It's also one way I get my aggressions out when I'm pissed off after a frustrating job. I kill a lot of my virtual colleagues with my stun gun on Virtual Cop. I also like Mortal Kombat III. I used to play a lot of Doom, but I got to the final stage and got sick of it.

5. Watch TV.

6. Rent or go to a Movie. My all-time favorites are *Star Wars*—I saw it for the first time when I was eleven—and *Forest*

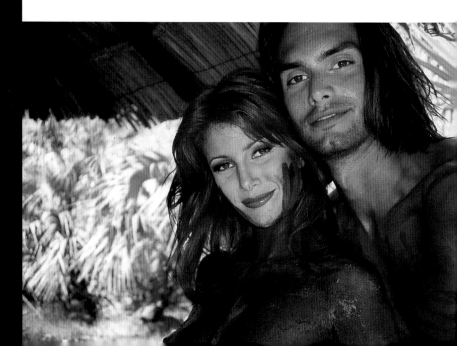

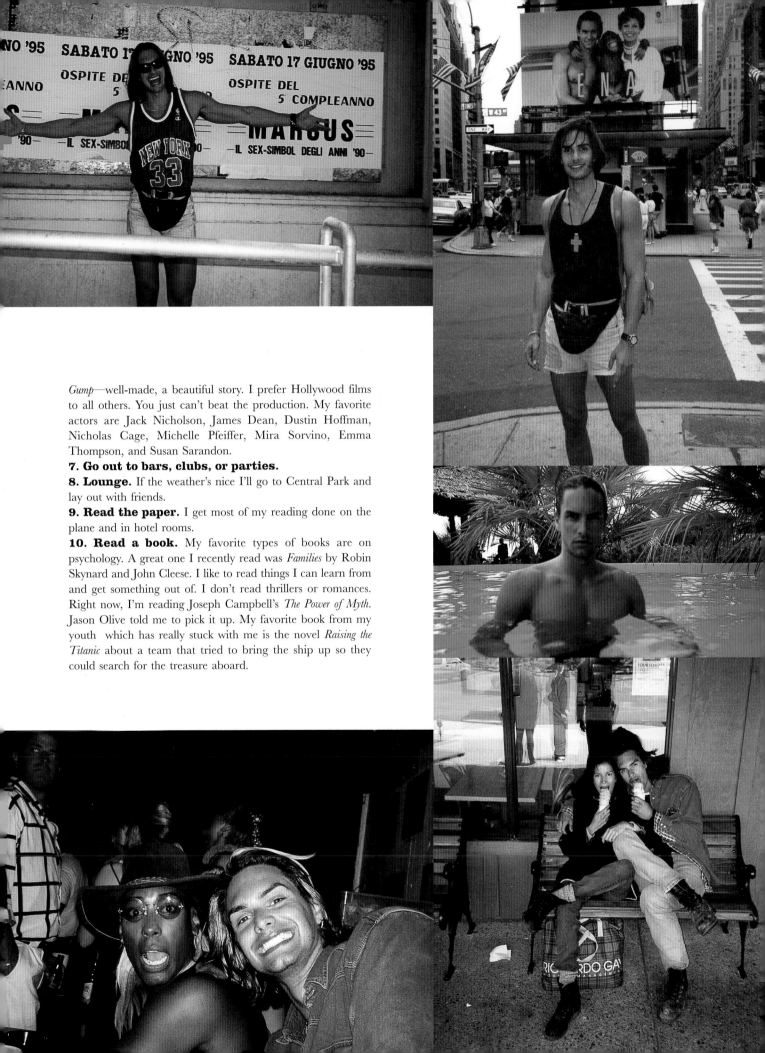

Gump—well-made, a beautiful story. I prefer Hollywood films to all others. You just can't beat the production. My favorite actors are Jack Nicholson, James Dean, Dustin Hoffman, Nicholas Cage, Michelle Pfeiffer, Mira Sorvino, Emma Thompson, and Susan Sarandon.

7. Go out to bars, clubs, or parties.

8. Lounge. If the weather's nice I'll go to Central Park and lay out with friends.

9. Read the paper. I get most of my reading done on the plane and in hotel rooms.

10. Read a book. My favorite types of books are on psychology. A great one I recently read was *Families* by Robin Skynard and John Cleese. I like to read things I can learn from and get something out of. I don't read thrillers or romances. Right now, I'm reading Joseph Campbell's *The Power of Myth*. Jason Olive told me to pick it up. My favorite book from my youth which has really stuck with me is the novel *Raising the Titanic* about a team that tried to bring the ship up so they could search for the treasure aboard.

Nuts and Bolts

foli

71

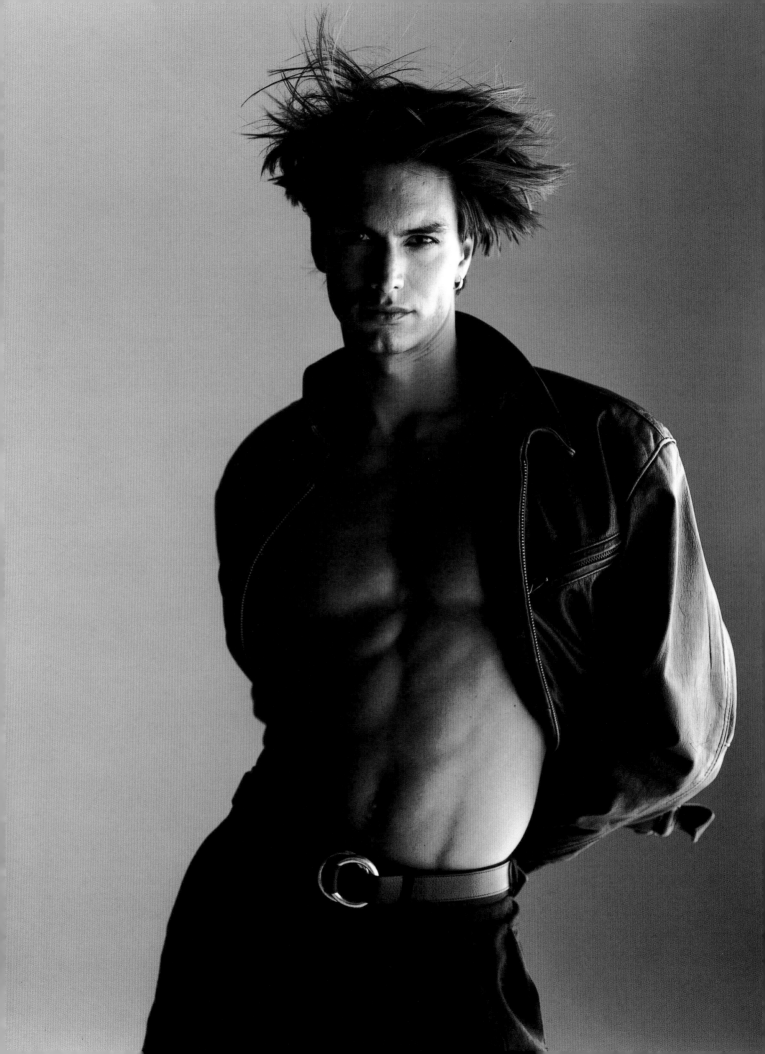

As agents, we are constantly in search of new models, hoping that he or she will become the next supermodel. If the talent is brand new, meaning they have absolutely no experience, the first thing an agent looks for is potential.

When a model has their initial meeting with the agent, there are some things they should be aware of:
• Don't wear makeup.
• Don't wear clothes that are too tight or too big.
• Bring any photographs you have, whether it's a portfolio or some loose pictures.
• Be yourself. This is the true key to modeling.

Agents make their decisions on the following criteria:

How tall? Men should be a minimum of 6 feet tall, but there are always exceptions.

Do or will you photograph well? Do you have an interesting look? Will you have an interesting presence in front of the camera? Can you work it? Are you comfortable enough to "go there?"

What changes in your appearance might you have to make? Will we keep your hair the same or will we have to cut it, change the style, or even the color?

Is your body in good shape? Do you need to lose weight or perhaps start building weight and muscle tone and how long do we think this will take? Time is always a crucial element.

What is your personality like? Are you easygoing? Will you be easy to work with? Will clients like you? Are you open-minded?

What type of work will you be best suited for—editorial, catalog, advertising? It's very important to be versatile enough to do it all.

Which market would you be best suited for, and where should you begin? Milan and Miami are great places to start, but if you are perfect for what's going on now, then you should be in New York or Paris.

When most of their criteria are met, the agents decide whether or not you will be right for their market and when they will want to start working with you. Sometimes this process can take up to a few months, but hopefully with the right people behind you, you should have a new book and cards in three weeks and start work a week after that.

The Agent's Eye
Ina Bloom

Left
GILLES BENSIMON
New York, 1997
Elle

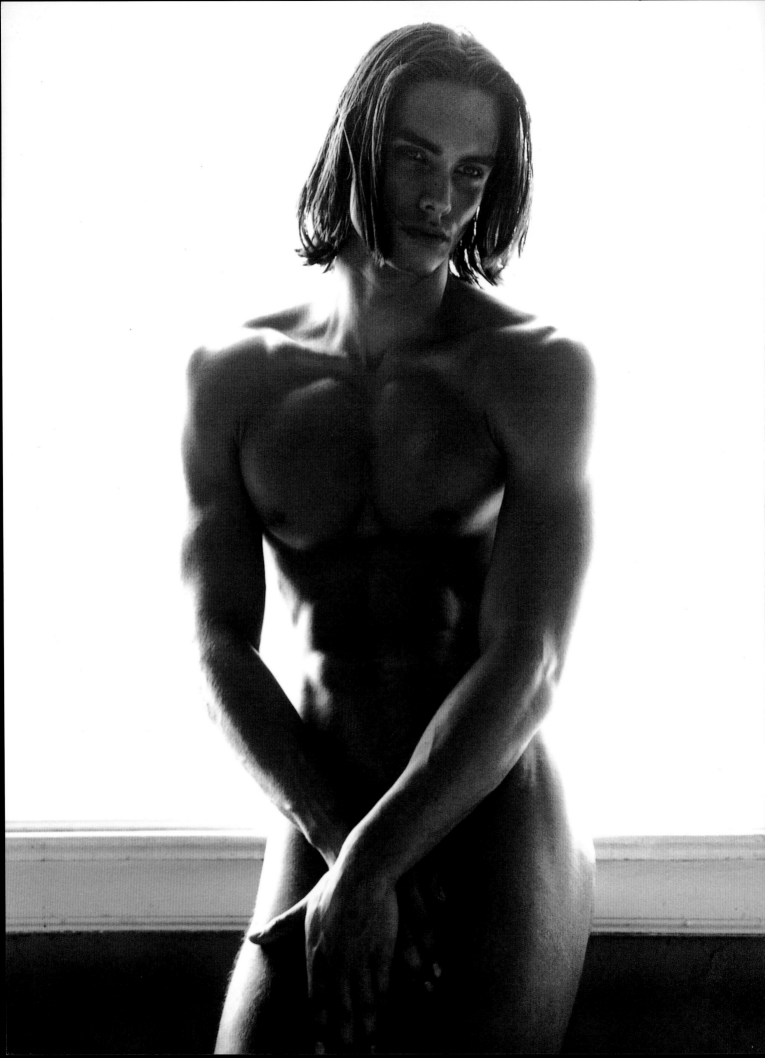

"Trish, How Do I Look?"

There are a lot more options for men and gone are the days of simple decisions. The line between functional versus fashionable looks has blurred, and you can now be as expressive with your appearance—while hopefully remaining within the boundaries of good taste—as women. However, no longer can you simply specify double- or single-breasted when asking for a pinstripe suit. Now you have to be specific: a single-breasted pinstripe suit with one, two, three, or four buttons; traditional navy with gray, or maybe red, lavender, or yellow pinstripes; narrow, bold, or irregular spacing; sack style or severely tailored. Designers have discovered, or perhaps paved a way for body-conscious men also to be fashion-conscious, and they've introduced forms, fits, and fabrics that, until

recently, haven't been available.

Designers that have long been the staple of every man's wardrobe are diversifying their lines, offering conservative clothing with a fashionable edge—emphasizing shoulders and waists in a classic suit, narrowing sweaters while widening pant legs. Sportswear has become high-tech—fashionable, flattering, and durable. While the options have expanded, they are tailored to a man who works on his body as well as his mind.

Which means one must be fit to slide into a sweater that emphasizes the arms, to wear a suit that nips the waist; and a flat-front pant requires abs that have experienced, more than once, the ultimate crunch. To be well-dressed requires a well-toned body.

While the line between fashion and function blurs, so too does the line between merely taking advantage of your new options and becoming obsessed with appearance. Male vanity may be on the upswing, but doesn't vanity rest in the realm of womanhood? As you and your gender "discover your look," will women be forced to

compete for mirror space? Will the "toothpaste cap" cohabitation complaint become second to "buy your own pressed powder compact" in the new millennium? And if you guys are spending more time in designer departments of retail stores, is it inevitable that I'll soon find myself at a hair salon, sitting next to you getting double-process highlights while testing masculine makeup foundation on your wrist? The thought may inspire a great many cosmetic conglomerates to thrill at an expanded market, but I pray that men maintain their insouciance about fashion. And that, while blurred, the line between incorporating new options and obsessing about being fashionable, will never be broken.

**Trish Becker
Bookings Editor, GQ**

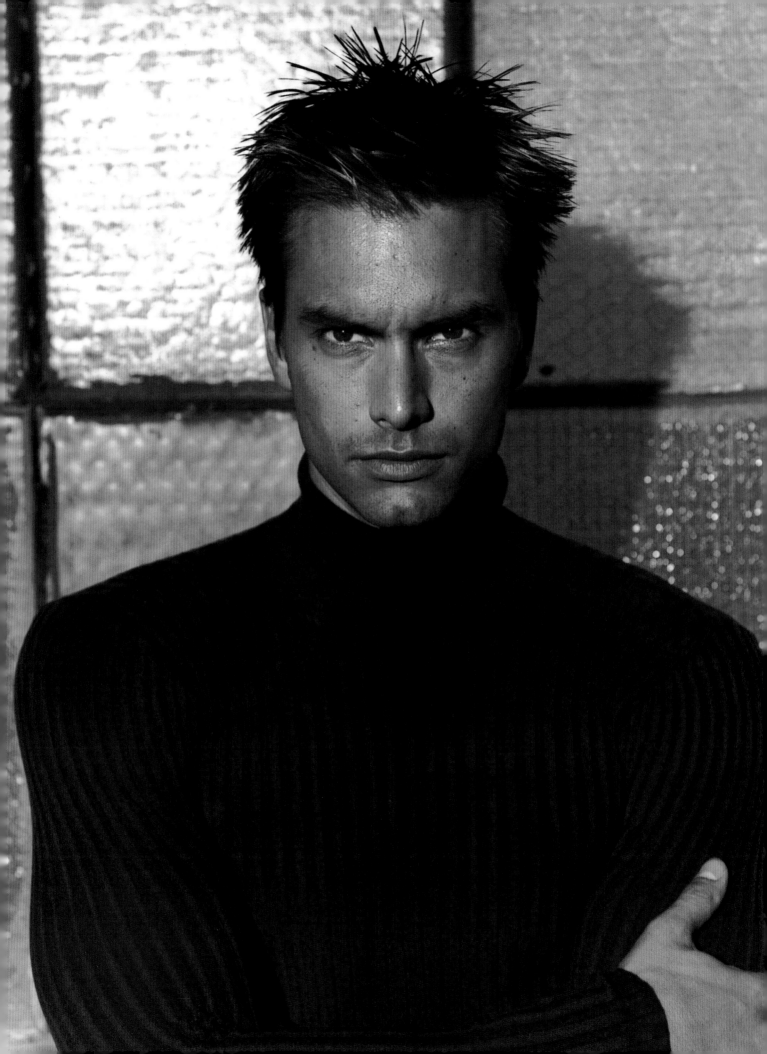

Secret Agent Advice:
how to look like a model

(1) Don't try to create a style on your own. Collaborate with your agent for wardrobe and hair.

(2) First impressions are everything. Even if you can't afford designer clothing, a standard "outfit" should be put together, regardless of your budget, to wear to meet clients and photographers. The more you put forth enough with your clothing, the more they will appreciate your effort.

(3) Don't forget your appearance as you frequent your agency. Your agent also needs to be impressed and excited with your appearance to promote you.

(4) Taking care of your body is of the utmost importance. This involves a healthy diet and regular exercise.

(5) You must confer with your agent on clothing sizes for you. If you don't follow your agent's advice, this could prove to be very harmful to your career, since the clothes won't fit!

(6) My models need to be somewhat tanned, so if you are in a city that is in the middle of winter, you need to frequent a tanning salon to maintain a healthy "glow."

(7) Proper skin care is not just for female models. Don't be shy about visiting a salon. If you have skin problems, it is imperative that you get facials on a regular basis or visit a dermatologist.

(8) If advised by your agent, it might be necessary to wax your chest hair. This should be done by a professional and maintained on a regular basis.

Sarah Hamilton Bailey-Shaul, Booking Agent

Left
ARNALDO ANAYA LUCCA
New York, 1996

Mr. America
Rich Baretta, fitness trainer
"Mr. America, 1987"

Left, Page 80
CONRAD GODLY
New York, 1995
Fit for Fun

When Marcus first joined the gym, he definitely made an impression. His hair was all one length to his chin, and soon every guy there had the same haircut. From the back, they all looked like Marcus—until, of course, you checked the body. I first met Marcus when he asked me for some advice on training to help him put a routine together. He has a very easygoing personality, and I was surprised to find that he's actually very shy around people.

How would you describe the way Marcus works out in the gym? He works very hard, doesn't socialize much, and really knows his way around. He loves to work out.

How do most people in the gym react to him? Women swarm around him just to get a look or to say "hi" and hope they'll someday be Mrs. Marcus Schenkenberg. Most of the gay men hope he's gay (wishful thinking). A number of guys time their workouts so they can be in the gym, and even the locker room, at the same time. Some people who've never met him think he has a big attitude, but they're just jealous, because once they talk to him they realize he's totally down-to-earth.

How would you describe Marcus's body type? Tall, but not lanky like most male models. In clothes he appears normal-sized, but in a tank top you realize how muscular he is.

79

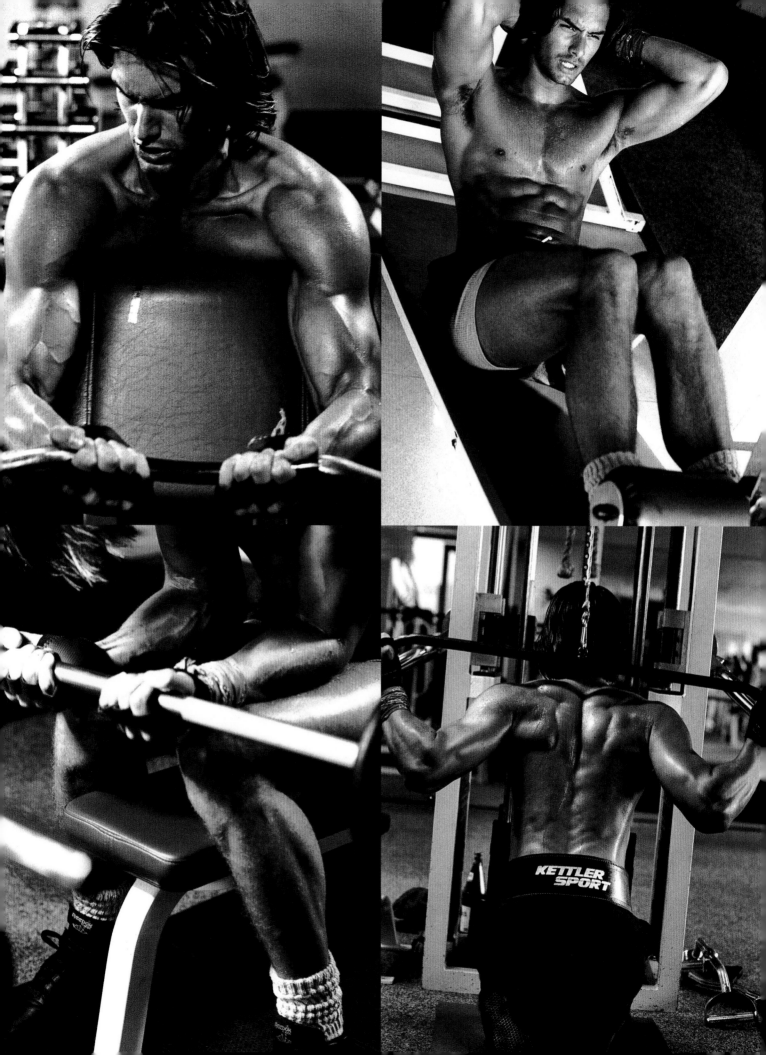

What type of fitness program does Marcus follow? He primarily relies on strength training. He uses a body-building style—he breaks up body parts and focuses on one or two muscle groups in each workout. For cardiovascular, he runs and plays basketball and tries to work it into his training by keeping his heart rate up, and by taking only short rests.

Is this what an average guy should do to get a body like Marcus's? It's what he could do, but Marcus has been training for many years.

What is completely unrealistic? To think you'll look just like Marcus. The only way to have a body like Marcus's is not just to train, but to have the right genes. You can only improve the body you were born with.

What are the common mistakes guys make when trying to get a body like Marcus's? (1) They don't know how to train properly, and they only focus on how much they can lift. (2) They only work their favorite body parts and neglect the rest of their body. (3) They only worry about how big they can get and not how symmetrical they are. (4) They think that to get big they have to eat enormous amounts of food, and they end up getting fat.

Marcus's Workout:

I always start my workout with ten to fifteen minutes of cardio warm-up, and work different muscle groups each day:
Monday: chest, bis, tris, abs.
Tuesday: legs, abs.
Wednesday: shoulders, back, forearms, abs.
Thursday: rest.
Friday: chest, bis, tris, abs.
Saturday: legs, abs.
Sunday: shoulders, back, forearms, abs.
I work my abdominals every day: four sets of about forty crunches, in four different positions to work different muscle groups. I always focus on keeping my stomach sucked in, so the muscles don't develop bulged-out.

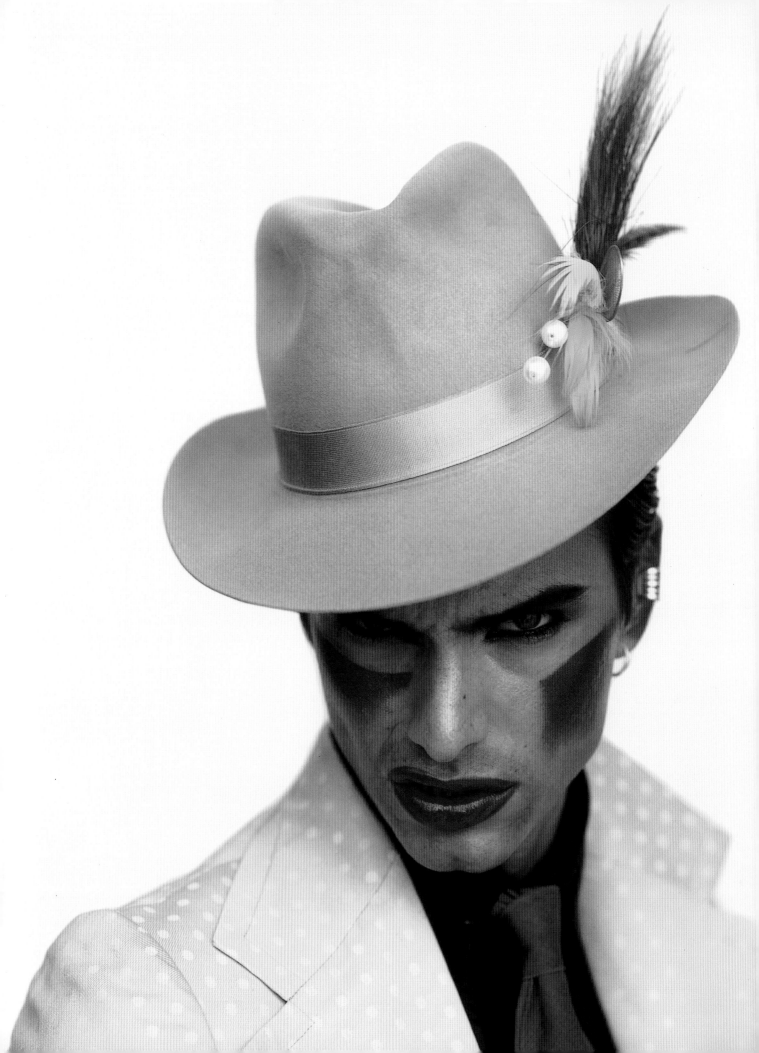

About Face
François Nars

Left
FRANÇOIS NARS
New York, 1997

Page 84
CARLO BOSCO
Sweden, 1994

Kate Sullivan: François, what do you think about men wearing makeup?
François Nars: It is very modern and sexy for men to wear makeup. It shouldn't make men look softer. It is a show of strength, and shows a man's level of comfort with his masculinity. Only society of today says that men who wear makeup are feminine. Where does this dictate come from? Certainly not history—from the Egyptians to the Victorian era, men have traditionally worn makeup fashionably styled to the times. Only in recent decades has society created a stigma about makeup for men. Men not wearing makeup was one recent evolution; now we are seeing another.

KS: Where are we seeing this right now?
FN: Tom Ford at Gucci had guys walking down the runway with makeup on and the effect was unbelievable. It was risky, but it worked. The guys looked sexy, confident, and normal. Everyone loved it.

KS: Why did you choose Antonio as your inspiration for Marcus?
FN: I love the way Antonio as an artist chose to draw men. It's like madness. The red and blue colors just explode into a vivid palette to reflect the strength of the man. I chose this artistic expression to exemplify the power that the makeup gives to Marcus. The effect is one of roughness, fierce masculinity, and confidence. I think that Marcus this way perfectly exemplifies Antonio's drawings. It is not a literal portrait, but one that reflects and draws inspiration from the art. It is about expressing yourself, and makeup is one way to do it.

KS: How would you see Marcus wearing makeup?
FN: Marcus's face is like a sketchbook—he can be natural or go all the way with makeup. He is artistic in his approach to modeling because he can feel what the picture is about and play that up for the camera. Because of this, and because he is open and accepting of change, he is definitely a man who can wear makeup and still be himself.

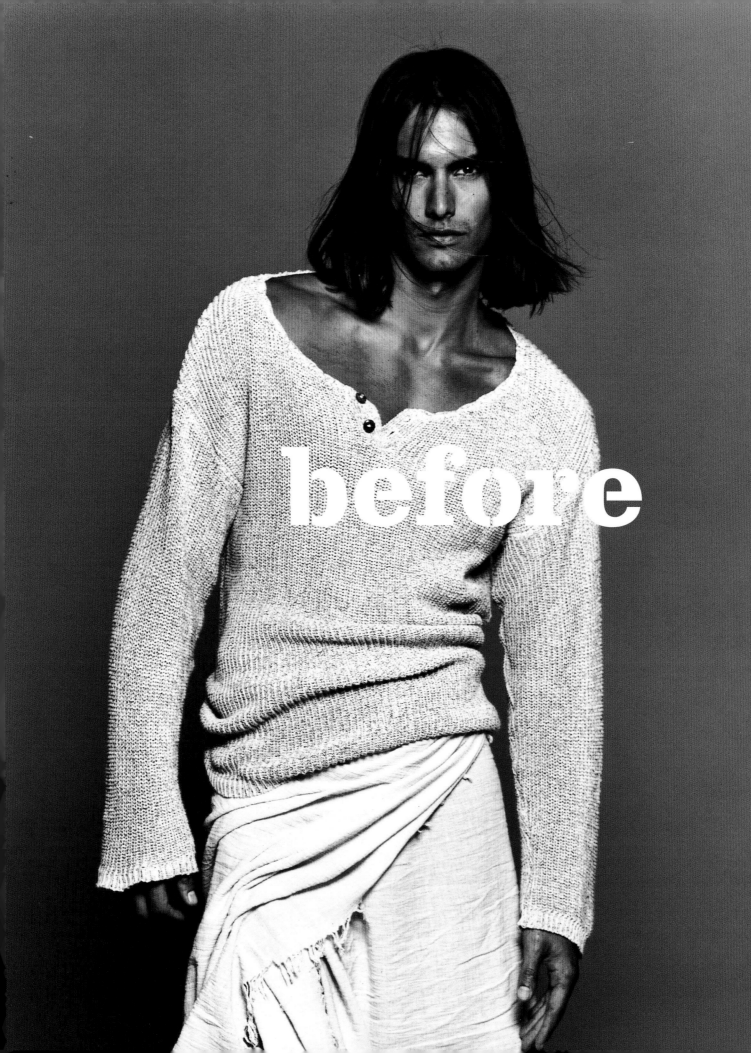

before

"The Haircut was big news, underscoring the newfound status of male models. We've gotten used to press coverage of the cosmetic mutations of female supermodels—say Linda Evangelista's haircolor-of-the-week—but no man this side of Dennis Rodman has attracted more attention for changing his 'do than Marcus Schenkenberg. It's the most famous haircut since Bill Clinton stopped traffic at LAX." Candace Bushnell,

International Collections for Men, Summer 1994

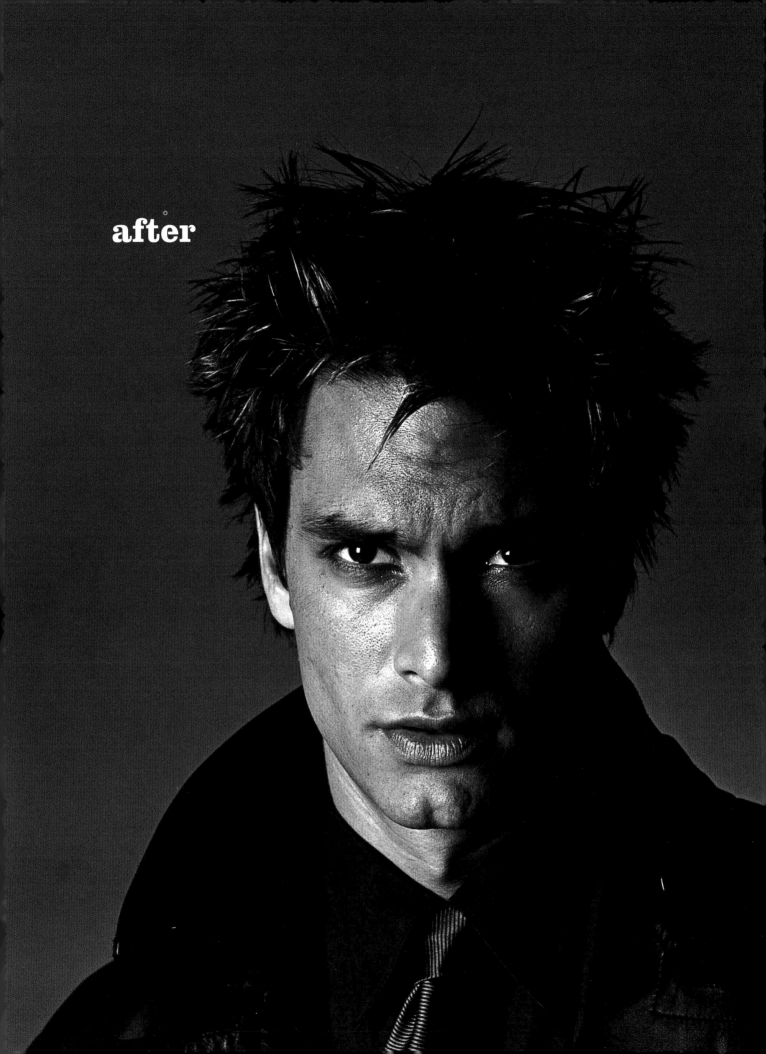

after

Lighten Up: Brad Johns Improves on Nature

What hair advice would you give to men? It's 1997! Men must start coloring their hair. All hair looks drab when you get older. Color makes everyone look better. Color is an improvement on nature. You should, however, only try certain things with your own color. You shouldn't be garish, but should instead look like a child at the beach, or a surfer—and your hair should *always* be expensive-looking. It's time to move ahead. It's time for men to make a statement: "Yes, I color my hair." Every man should have their hair colored by the year 2000. That should be the goal of the planet.

What would you recommend I do with my hair, Brad? You have such great taste, Marcus, and usually know what you'd like, so you know I usually agree to do whatever you want.

Yes, but if I walked in today and said you could do whatever you wanted, what would you do? I know exactly what I'd do. I would first lighten all of your hair to a light brown, and then I'd put big, baby-blond pieces—big chunks—in the front. If you cut your hair really short, like an inch short all over, I would bleach it all out to a sandy beige color so you'd look like a surfer. But if I were to choose one style for your hair right now, I'd have you grow it all out to one length at your shoulders so it moves when you walk, and then I'd lighten it to a sandy beige.

Why lighten it? The sandy beige color would bring back that brightness you had when you were little. When you first started modeling you had that long, dark, exotic hair, but I think you should do something that's really different now. After all, you are the first male supermodel. I knew it when you walked into the salon. All the women supermodels color their hair, and if anyone can do something that bold, you can. You must!

Opposite
MICHAEL TAMMARO
New York, 1996

Page 88
BRUCE WEBER
San Francisco, 1991

11.01.1996

HAIRCUT! Up at 9:30am. Tired and jetlagged, I still wasn't sure I wanted to go through this. I've had long hair since the beginning of my career—known for it. A bit concerned, but I needed a change and have been talking to Jason about it for awhile. Decided to do it right before the Milan shows so everyone would see my new 'do. Went with Bruce Weber's suggestion of a French Foreign Legion look. When I got to Garren's studio, I found out *Entertainment Tonight* was filming! Journalists and press there, too. Not really in the mood for this. After Garren cut it, I ran my hand through the back, and there was nothing there. He cut it way too short. Everyone said it looked great, except Jason. He also thought it was too short. He's probably the only one who'd tell me the truth. Good thing my hair grows fast. Home to pack. Butch stopped by. Left 3:00pm. Picked up Jason and Sara at the agency. Saw Jason's new apartment. Flew 6:00pm to Madrid.

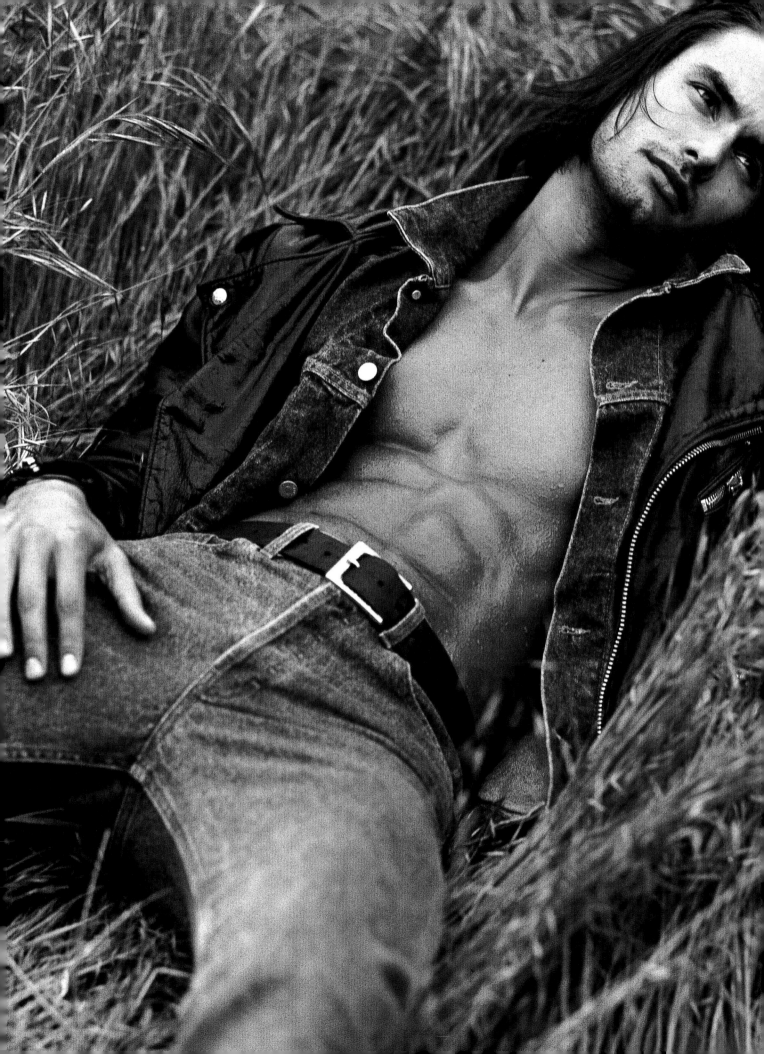

Marcus Mode

#5 clothes

everyday/weekend:

Shirts: Long-sleeved, cotton, button-down: white, blood red, dark blue, black, denim. T-shirts: white or black.

Pants: Jeans: black, blue, and white in the summer. Leather: ten pairs black and brown—some designer, but most bought in the Les Halles district of Paris.

Underwear: Briefs, long and short. Boxers when lounging at home.

Shoes: Black survivor boots (mountain-climbing boots). Black motorcycle boots.

Jackets: Short, black leather. Down parkas: black, blue, red.

Jewelry: Watches: Rolex, Rado. Big leather belt. Leather necklace with a rock I bought in San Francisco during the Calvin Klein shoot. I bought a matching one for Maureen. Bracelet from Donna Karan show. Earring: small, silver hoop.

evening wear:

I have seven designer suits, all dark colors. I prefer a black "Reservoir Dogs"-style.

black tie:

Tux, of course.

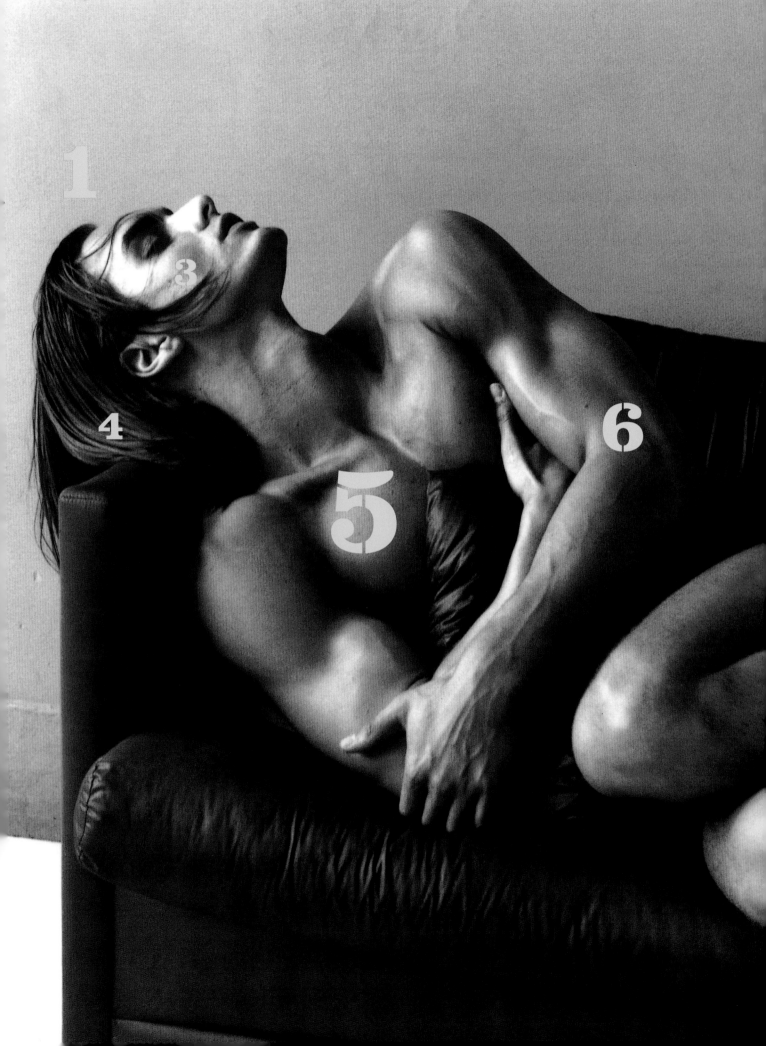

com-
plete:

**(1) height:
6 feet 2 ½
inches
(2) weight:
188 pounds
(3) eyes:
brown
(4) hair:
brown
(5) shirt:
16" x 35"
(6) suit:
42 long
(7) shoe:
10 ½**

STEVEN MEISEL
New York, 1992

The Payoff

five

93

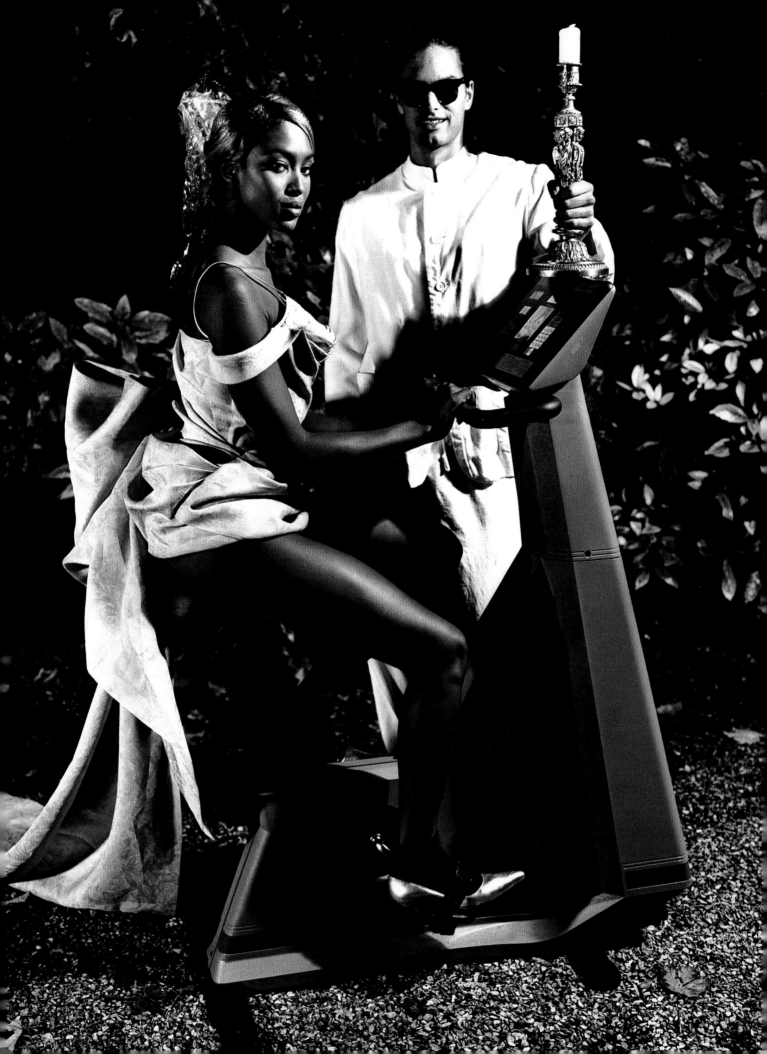

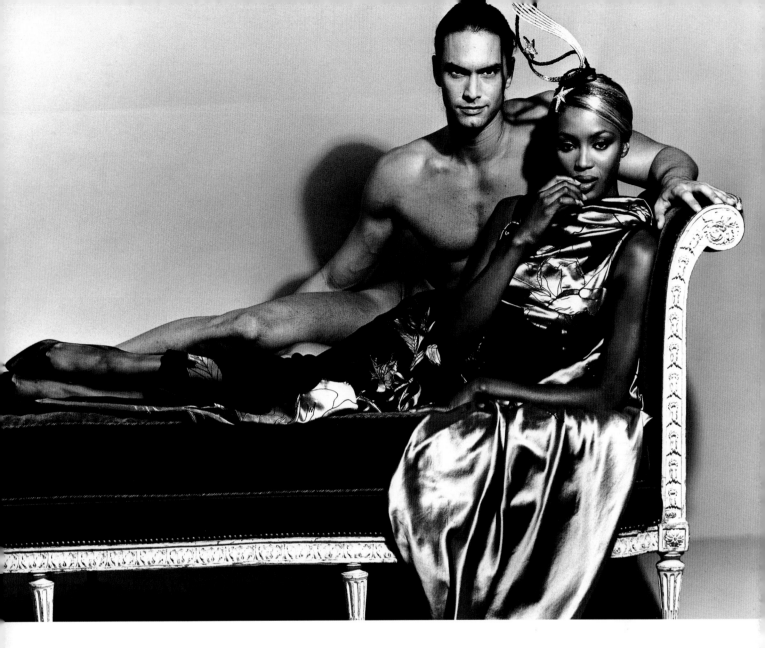

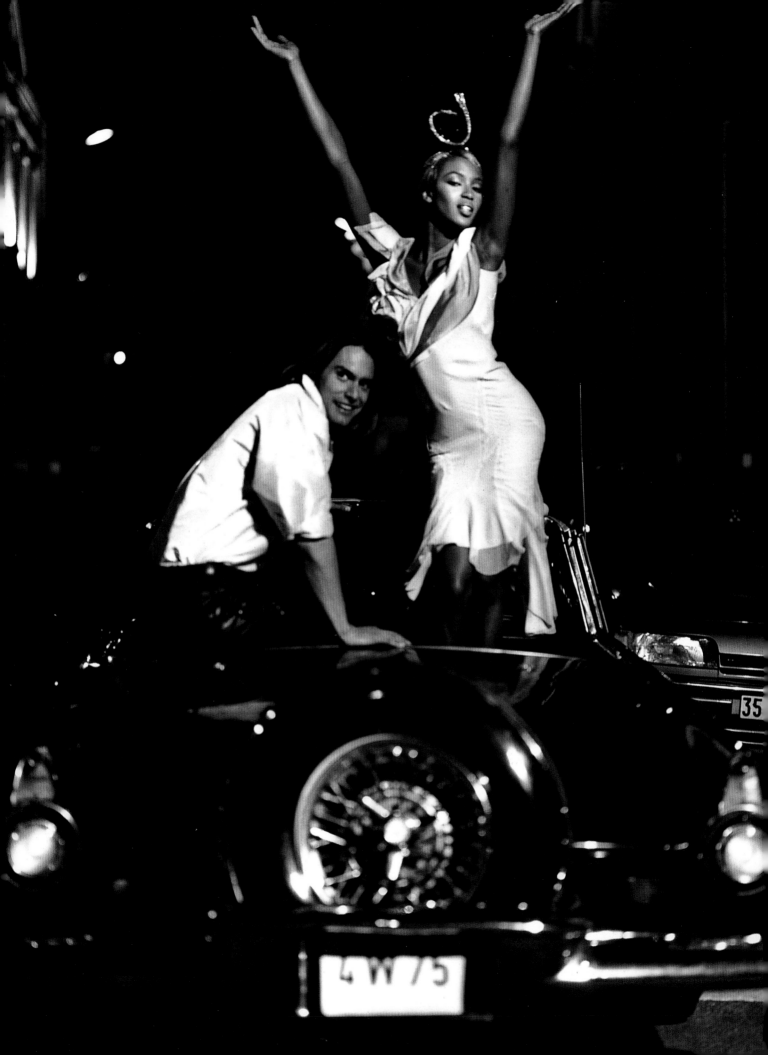

e–z money:

So there's fame, beauty, glamour, women. . . but why do I really stay in this profession? It's very easy: money.

I don't have many expenses. I don't have a house, a pet, a car, art, or any of the other things people blow their money on. I'm never in one place, so I wouldn't even be able to use any of those things right now. My job takes me around the world and the few designer clothes I have were given to me. I've seen so many people lose everything they earn because they weren't smart about it. I'm hoarding my money in savings and investments. I studied economics in school, and my family gives me great advice, so I know how to manage money. So, for me, being the highest-paid male model means security later on. My next goal is to get involved in some business ventures.

I did recently buy my own apartment in New York. It's closed to the public, but I'll tell you a few of my favorite toys that are inside:

- Alarm clock with voice control: I can scream obscenities at it in the morning, and it'll listen.
- 5 Watches: my favorites are a gold Rolex and a sleek, black Rado.
- Sound system with 3-foot speakers: very expensive, very loud.
- Big-screen TV.
- 3 VCRs: 2 VHSs, and 1 European multisystem.
- 3 video-game systems: Sega Saturn with stun gun, Nintendo 64, Sony Playstation.
- Laptop Computer, TI 560CD.
- Handicam.
- 2 mountain bikes: Vectra and Iron Horse–great for riding to Sheep's Meadow in Central Park.
- Travel-size point and shoot: for once, I'm behind the camera.

Pages 94–96
KARL LAGERFELD
Paris, 1995

97

idolatry and fame

You just have to loo

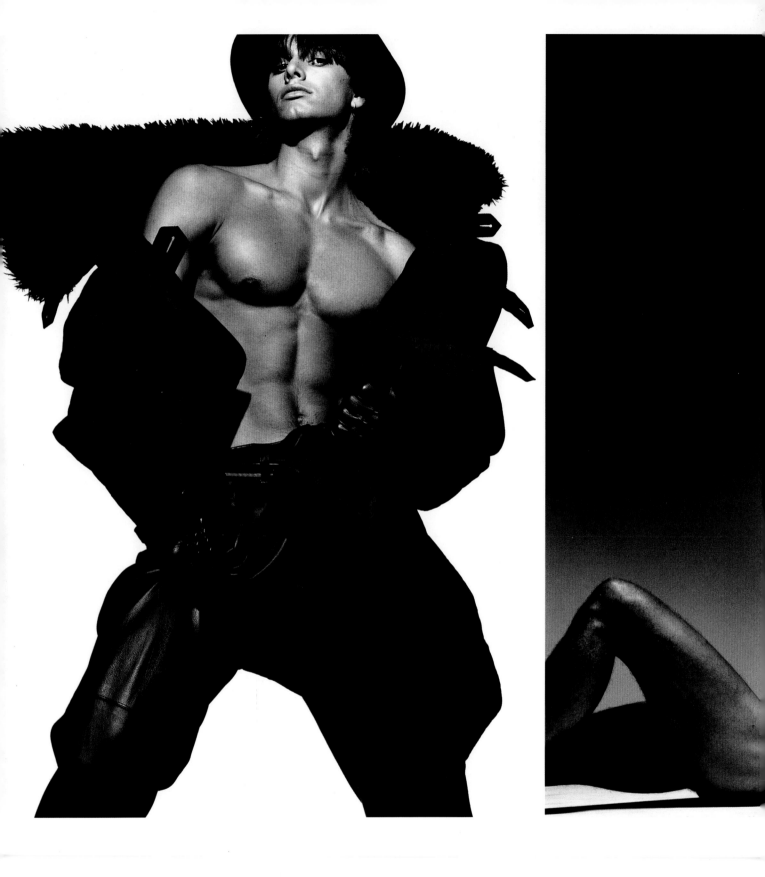

t him. He's fabulous. He's got a fabulous body,
face, and attitude. Francesco Scavullo

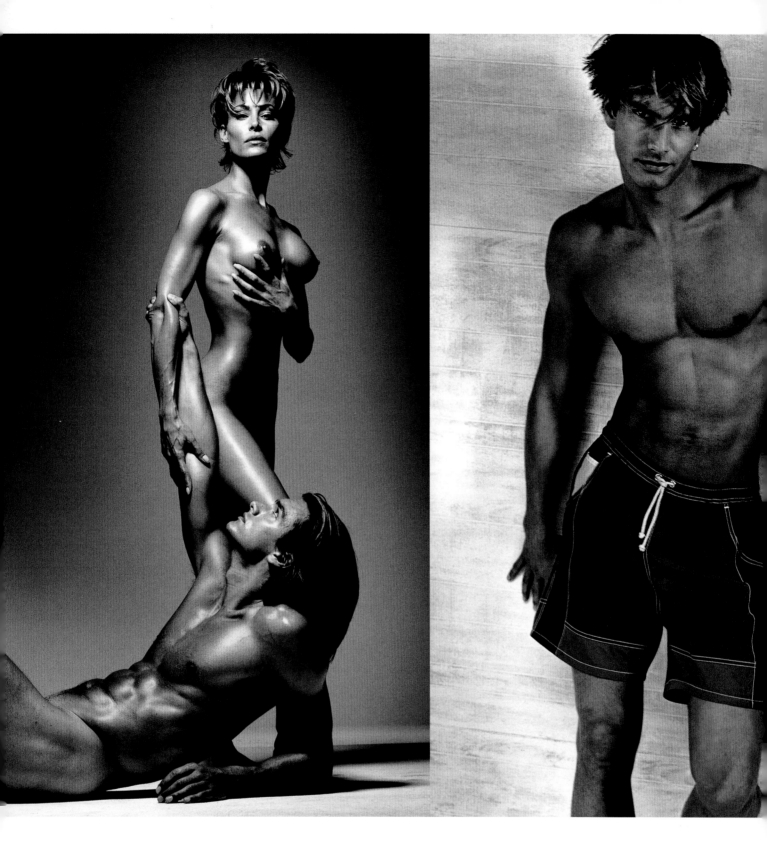

Talk about perfect. Marcus's bod

100

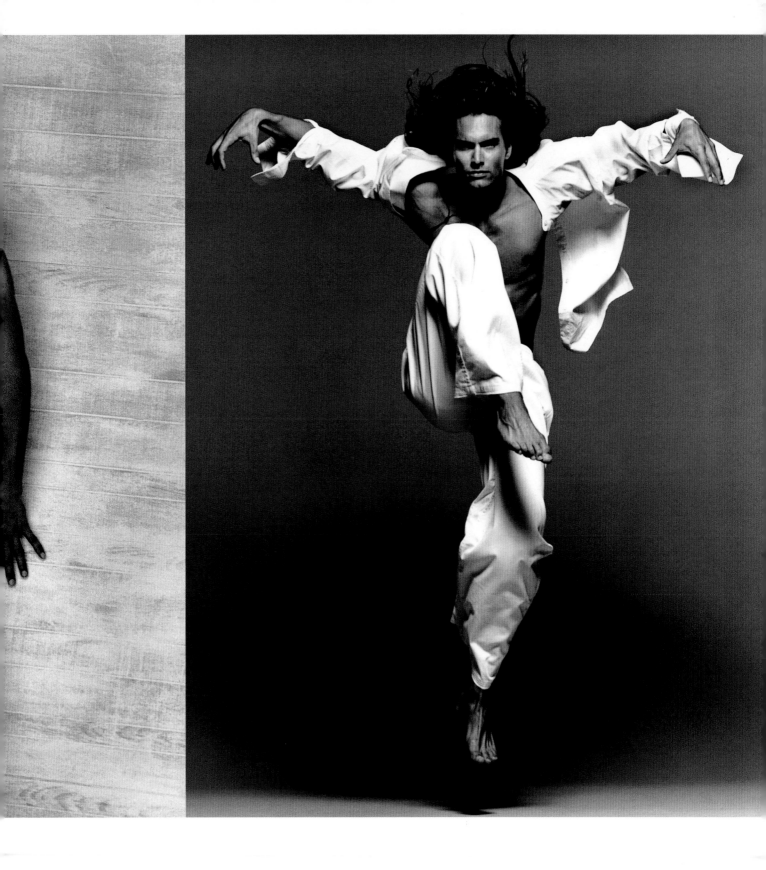

; like sculpture. His stature makes a statement and lets the clothes come alive. Donna Karan

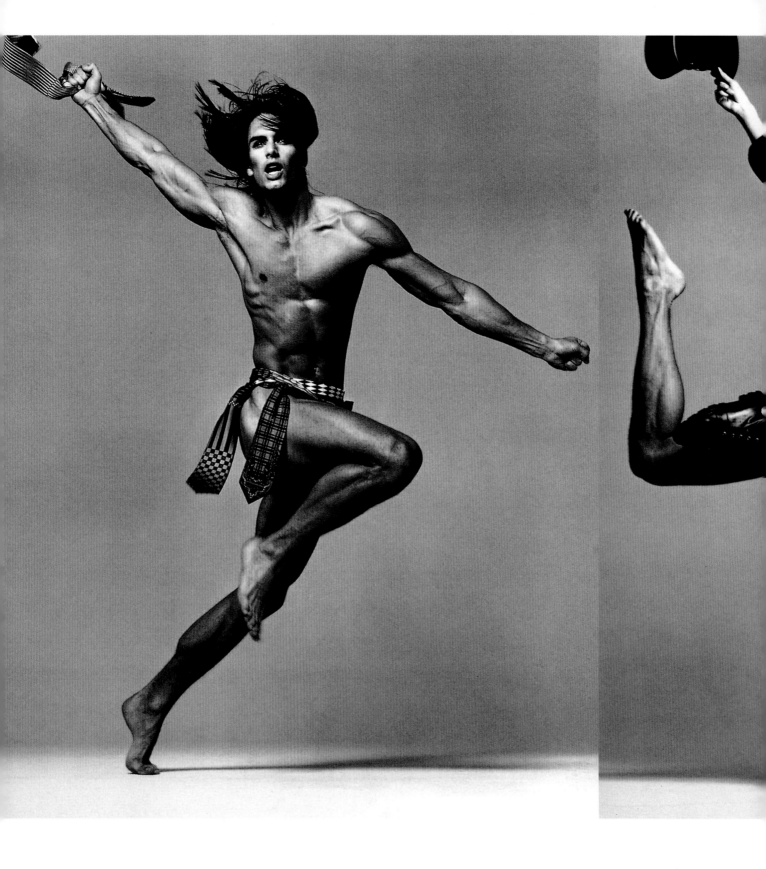

Marcus photographed with Stephanie Seymour by Richard Avedon.

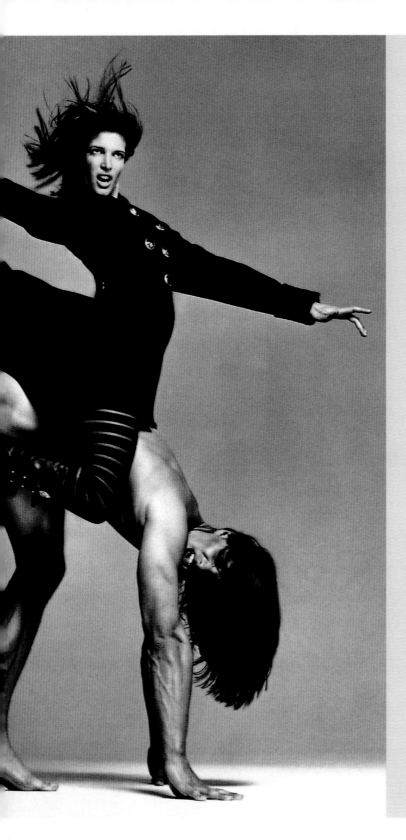

for Gianni Versace

"Marcus Schenkenberg is so good-looking it is, frankly, preposterous. He's a cartoon fantasy man, etched from the pen of an artistically gifted 10-year-old girl who thinks princes ride white horses and live in pointy-spired pink castles in the sky.... And then he sits down next to you with his shirt off and

you think, "There is so much bloke here." His chest is a two-seater sofa! So you avert your gaze and start making terrible jokes about his disgusting fake-snakeskin cowboy boots instead, peering at him as if he were an alien curiosity. Which is exactly what he is."

Sylvia Patterson, *Clothes Show*, July 1995

PETER BEARD
Tokyo, 1993
Esquire Gentleman

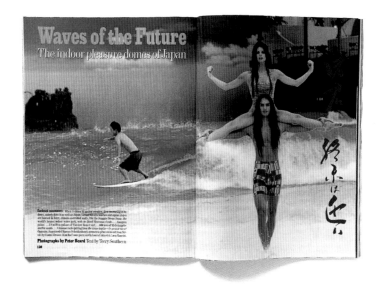

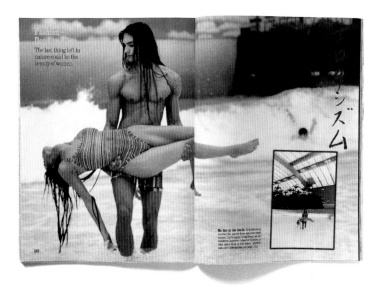

04.23.1993

Last day of Versace shoot with Richard Avedon and Stephanie Seymour. My whole body is aching from jumping and doing all these crazy things on the concrete floor. Very uncomfortable for the first two days, since I was buck-naked and there was a huge crew in the studio. Fifteen people—assistants, dance choreographers, everyone from Versace. The first day I tried to hide behind Stephanie when we were just standing around waiting between shoots, since she had a dress on. Stephanie just left Axel Rose and was there with her boyfriend, Peter. I had a big crush on her when I first started modeling. She is very nice, extremely sexy, and sweet. We worked really well together and knew what we wanted to do with the shots, so we were able to get rid of the dance choreographers and some of the crew, and choreograph the poses ourselves. We really pushed ourselves. Avedon was great, too. So professional and so full of energy—I couldn't believe it. He was running all over the studio. Both Stephanie and I feel that these are the pictures we're most proud of. Went straight from the studio to JFK, where I met Angie Everhart. Flew to London with her overnight for connection to Africa for the week-long *Esquire* shoot with Peter Beard.

04.25.1993

Peter met us at the airport in Nairobi, yesterday. Knew Peter from Maureen—she went out with him years ago, and we worked with him on the last *Esquire* shoot. Peter's nice, but a crazy man. He uses words you don't understand, and I never know what the hell he's talking about. Woody from *Esquire* warned me to be really careful on the trip. Said Peter's judgement isn't the best and, last year, a guy he was photographing in Africa was eaten by a crocodile! I know Peter's crazy, but it still made me nervous. Took a car out to his ranch, Hog Ranch. Very strange place to be, but exciting. Totally surreal after being shut up in a concrete studio for five days. Giraffes walked up to us during dinner by the campfire tonight. Peter shot some pictures with a snapshot camera while I fed them with my hands. I saw so many exotic animals: lions, zebras, elephants. I'm glad I brought my videocamera! We're sleeping in tents—gets really black here at night.

04.30.1993

Went out to Lake Rudolph to shoot today with some of the locals that Peter knew. Peter stepped on a nail and didn't do anything about it, so he walked around with a hole in his foot all day. Angie's been acting a little strange and distant—I think she's upset about her breakup with her boyfriend. We ran out of bottled water so we had to drink from a spring. Peter told us it was some of the purest water in the world. But he drinks all the local water and eats all the food. After the shooting was over, the locals started doing a ritual dance, so Peter had them dance around Angie and me. We danced with them, and it was totally free and wild.

05.01.1993

Up 7:00am. Flew to London. Stayed at Heathrow Hilton overnight. Angie complained that she felt a little sick. As I walked into my room I started feeling sick, too. Had to run to the bathroom all night. I guess Peter was wrong about the spring water.

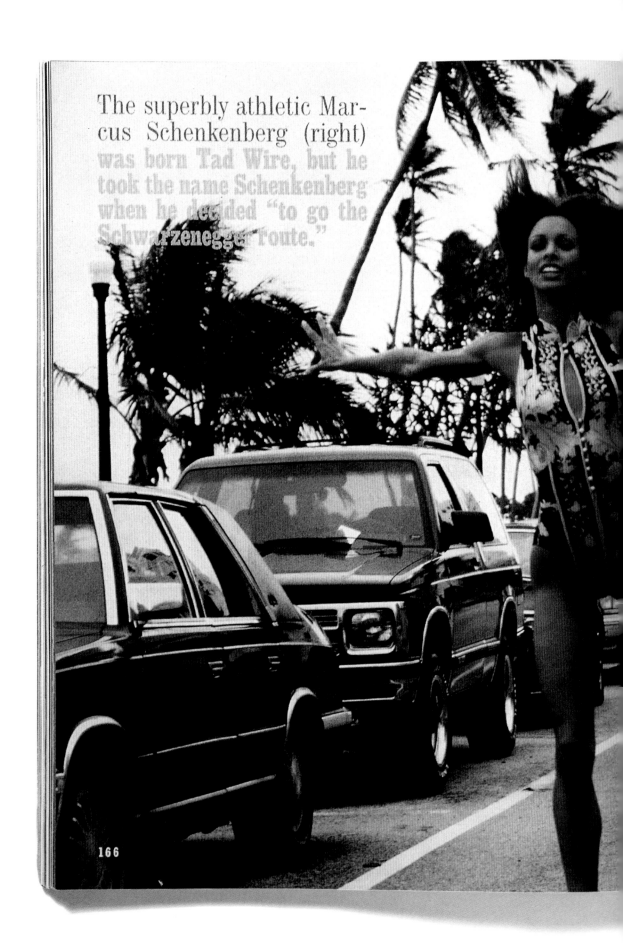

The superbly athletic Marcus Schenkenberg (right) was born Tad Wire, but he took the name Schenkenberg when he decided "to go the Schwarzenegger route."

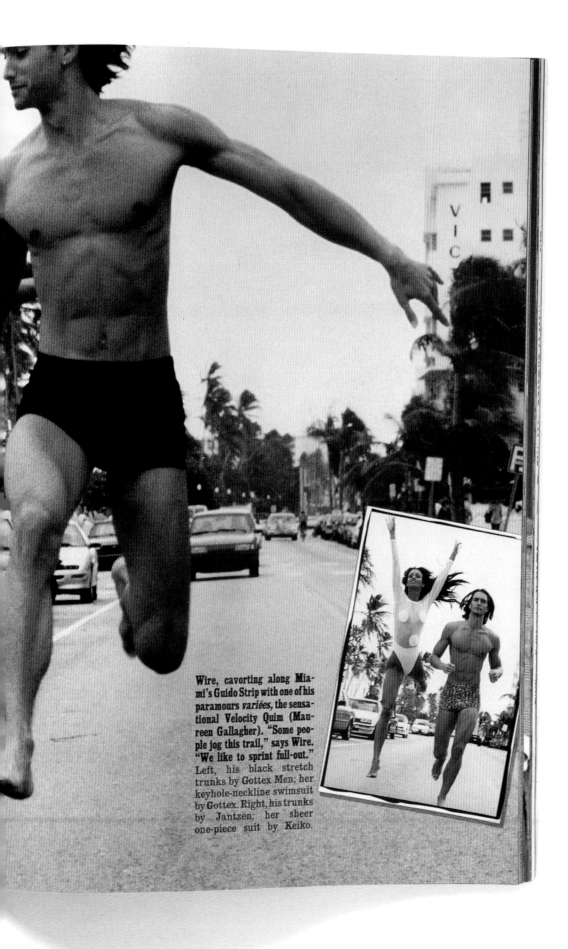

PETER BEARD
Miami, 1992
Esquire Gentleman

Wire, cavorting along Miami's Guido Strip with one of his paramours *variées*, the sensational Velocity Quim (Maureen Gallagher). "Some people jog this trail," says Wire. "We like to sprint full-out." Left, his black stretch trunks by Gottex Men; her keyhole-neckline swimsuit by Gottex. Right, his trunks by Jantzen; her sheer one-piece suit by Keiko.

APRIL

Marcus

29 **M O N D A Y**

STOCKHOLM

stockholm

| Contact |
| Day / Hour Rate |
| Travel Time |
| Cancellation Fee |
| Usage Terms |
| Billing Address |
| PO Number |
| Agent |

30 **T U E S D A Y**

Gruppen

Armani show

Cafe mag

editorial

310-208-

1 **W E D N E S D A Y**

TODD OLDHAM

AIDS PROJECT LOS

Book soup signing

tonight show Jay Leno

APLA show

fax / 310

phone

Germ cat

MYC 7000 DM

MARCOT AIR

JEFF TUTTLE

BREWER 4 DAY

JOHN PRAYER

MICHAEL DUVERS

2 **T H U R S D A Y**

Todd Oldham

AIDS PROJECT

LOS ANGELS

Kevin

3 **F R I D A Y**

phone

10.000

appearance

12.18.1993

Up at noon, still on Tokyo time. Went to work at Industria. Shooting with Michel Comte and Linda Evangelista. We were all in a good mood and laughing, and the shoot was very quick and fun. Michel took a few pictures, while Linda climbed onto my back. Not a bad day's work.

12.20.1993

Arrived at noon in London. Brad picked me up. Went to my calendar signing at a bookstore. Mostly teenage girls and some older men and women, too. Got the usual cards with phone numbers. Went to two interviews and then to a photoshoot for *Look* magazine. I was very tired, but tried to be positive and put as much energy as I could into it. The photographer was helpful and didn't push too hard, and the pictures actually turned out great. Went out for dinner with my friends from Sweden, Rebecca and Pia.

03.08.1994

Paris. Calta called and woke me up at 8:00am. Studio at 9:00am. Seemed like nice, genuine people—they only needed one picture. Took all fucking day though! They drove me crazy. So pissed off. Another model named Matt came in at 3:00pm for leg shot. Didn't get home until 5:00am. Went straight to bed.

05.11.1994

Got up—hung over. Went grocery shopping and to the gym. Saw Mark there. Home to get dressed in the clothes Valentino picked out for me to wear to his birthday party. Picked up Angie Harmon in a limo and took off to Valentino's apartment. I've been there before—very beautiful. His parties are always the most elegant—and also probably the stiffest. When we first got there everything *was* very stiff. There was dinner and about twenty waiters. I met Sharon Stone at the buffet. She said, "The food looks really great." I agreed. What could I say? After dinner and five glasses of champagne everything loosened up a bit. I was introduced to Elle MacPherson and her husband, and was invited to lunch with them and Valentino. Got home late—sloppy.

03.25.1996

Up at 7:30am. Went to do the *American Journal* interview at breakfast with Matt & David. Larry King was eating there and decided to join us. Back to hotel. Went to another Academy Awards rehearsal. Did the red carpet entrance. Then changed. Did the opening number! Fourteen of us did a runway show modeling the movie costumes, and then presented the costume awards. I wore the Richard III costume. Changed quickly into our tuxes, and got to relax and watch the rest with Jason and Patricia—great! We had fifth-row seats, right in front of Tom Cruise. Really miss Rosemarie, though. Wanted so much to share this moment with her! Went to governor's ball after, ate dinner, drank. Home 12:30am. TV. Called Rose in Paris. Slept.

A Model Life

113

Catwalk: Man on Show
Kevin Krier

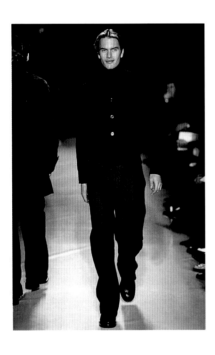

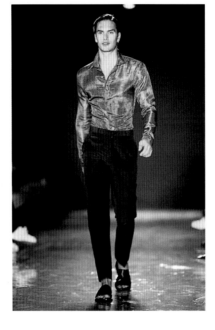

Left
Donna Karan Menswear
Fall, 1997

Right
GERARDO SOMOZA
Donna Karan Menswear
Spring, 1997

Right
BRUNO PELLERIN
Givenchy Haute Couture
Alexander McQueen Show
Spring, 1997

Jason Kanner: Marcus, do you ever get nervous on the runway anymore?
Marcus: No. It's like walking down the street—like walking down Fifth Avenue.
Kevin: That's one of the directions I usually give to the models. We've already booked them, so we already know how they walk. The minute you try to make the models walk in a way that isn't natural for them, they become tense and they project *awkward* instead of *confident*. But, Marcus, I can think of one time when you might have been nervous: the APLA benefit show last year for Todd Oldham, when the audience was so completely wild. I'd never seen anything like it. From the first second that Naomi hit the runway, the audience screamed, cheered, whistled, and carried on to a point that I was literally scared for the

models. I mean, here we've got this black-tie audience that paid $25,000 a table to be there, and acting like they're at a football game! Every model was like a touchdown. Then, when they introduced the men, Marcus was the first male out. You would've thought he was naked! I was giving him signals at the front of the house and I was so scared for him. But Marcus gave his little smile to say, "I'm there"—it's internal, the smile—but I thought, "My God, just walk, walk, walk, walk, walk."
Marcus: That *was* crazy. But it's so much more fun to do a show when the audience gets into it like that.
Kevin: That was a little much for me, but spontaneous applause *is* great when it happens, it's just so rare. You usually see more of the polite clap. But the only time I was ever scared was at that show. I was so afraid for the models. I thought the audience was going to stampede the runway. It's like they thought that once they paid for the tables they got to sleep with the models. That's model harrassment—you can't do it.

Marcus, do you remember the first show we ever did together? It was that huge international show for *Esquire* magazine. Your Calvin Klein campaign had just come out in *Vanity Fair*, and I remember seeing it and saying, "Who *is* this guy? I have to see him *now*!"
Marcus: Yeah, that was a great show. But don't you think it's amazing how much bigger men's shows are now?
Kevin: Definitely. When people consider *fashion* they usually think about women's instead of men's. I think that's changing much. Designers are taking men's fashion much more

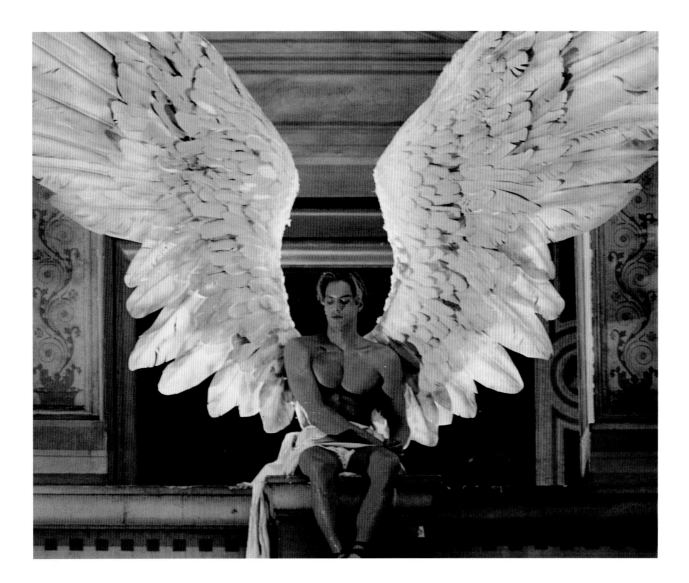

seriously, and the entire business has really grown. There is now, as there has been for women, a men's season in all the major capitals: Milan, Paris, New York, London, Tokyo. This has had an effect both in and outside of the industry, to the extent that in a show we can remake and rethink how we look at clothes by how we might see them on the runway; and seeing them in that way we become stronger and clearer about how we might look at them in general. There's also about ten times the amount of press attention on the men's lines as there used to be. There's certainly a lot of reasons for that. With the advent of designers showing strong collections there's so much more media coverage. Also, being able to incorporate the superstar into it: We now have male models who have the lead roles that women have had.

Jason: What exactly goes into producing a show?

Kevin: I have two different roles: In effect, the roles of a producer and a director in a theater. As the producer, I raise money for the show, and impact it creatively to some degree; as the director, I see it realized on the stage. I have a public relations firm that specializes in fashion show and event production, and we produce and direct about fifty fashion shows a year. What I do, specifically, is work with the designer to go over their design for that season, develop a concept for the collection, and then figure out how best to bring it all to life. I'm always working hand-in-hand with the designer. That's why I say I'm like a director in the theater. The role of the playwright is the role of the designer. They've put the words out there and it's my job to realize those

"Any guy who's played a sport, has danced, or has done something that involves the body, understands that he probably looks better standing up straight than hunched over."

words—in this case clothes—in the best way possible. So we manage and execute all elements of production, from building the set, choosing the music and lighting package, deciding where the show will be held, and administering where the buyers and critics are seated. We also work on staging: choosing the music, casting the models, organizing the back-stage—the dressers, the steaming, the pressing, the alterations, the fitting schedule—all of it.

Jason: Do you personally direct the models?

Kevin: I'll stage them, and we'll have a rehearsal.

Jason: What does it take to prepare the models?

Kevin: I'll do a walk through with them, and I'll say, for example, "I need you to walk four steps behind these three guys and then slow down here, and you'll be creating an arc . . ." Then I'll work individually and talk to them one-on-one, "Remember that they're only ten feet behind you and you can't let them catch up with you . . ." We usually have a meeting before the show as well. Once the guys are in their first looks, we'll again reinforce what the mood is and get them really jazzed about going out there. Then, when we're actually in the run of the show, I'm up in a booth calling all the cues: the light cue person, the set changes, as well as cueing James, who works with me and is the primary cue person for the model on stage. I'll say, "James, tell Marcus to go. James, tell Marcus to smile."

Jason: What do you do with a guy who can't walk or stand up straight?

Kevin: You work with them. Any guy who's played a sport, has danced, or does something that involves the body, understands that he probably looks better standing up straight than hunched over—and the minute he gets up on the stage, he'll probably stand up straight.

Jason: But don't you agree that there's a difference between standing up straight tense, and standing up straight relaxed.

Kevin: You just have to do it. It takes a

while. If a model was taught how to walk, they were most likely taught incorrectly. There is no school for modeling. With the new guys, I'll walk them back and forth fifty times in rehearsal until they get it. Or, I won't book them if I know they just don't have it. You know, not everyone can walk.

Marcus: Models will also work with the newcomers. I remember my first runway job—I had no idea what I was supposed to do, so the night before the show I asked this guy who had been working for a while to show me how to walk. So we just practiced walking in the hallway of the hotel, back and forth, over and over. But Kevin, you really worked with me and showed me how to do it. No one can walk like you can.

Jason: So how do you direct Marcus?

Kevin: I would probably only have to direct him to the specifics of the show. There would probably be a pattern that he follows and a mood that he has to convey. There are shows where the demeanor is more stern—more internal and less communicative with the audience. Other times we'll be doing a much happier show, where the models will convey a sense of enjoyment or confidence.

Jason: Do you cast your models to convey a particular mood?

Kevin: Absolutely.

Jason: What would Marcus's ideal role be?

Kevin: Marcus is a chameleon. He can have many moods. There are times that we'll want Marcus to be this strong, handsome, driving, confident man. Other times we'll play on the fact that he is so goddamn sexy. So the clothes he's going to wear, how he's going to walk—his stride and everything will reflect that. The great thing about Marcus is that he doesn't overact. He's not out there to use gimmicks or changes or things that signal to the audience "I am sexy." He *is* sexy, and that comes through without any extra effort. It's his confidence and knowledge that he can get out there and do that. But he also knows that when he's wearing a

six-button, double-breasted Savile Row suit, with a big pocket square and fancy shoes, it requires a certain manner and stride. And when he's wearing a g-string, his walk would probably be a little bit different—he wouldn't put his hand in front of "it," necessarily. So, there *are* times when you have to work with even the most experienced models, and that's why casting is so important. But I develop a retinue of talent and I usually know what I can expect from that talent. If it's a Marcus, I know what goes into that equation—it means he can be many things. He's also big, and will often be cast for his size. I work with many designers, Hugo Boss for example, who have a model that is Marcus's size, in order to build clothes just for Marcus to wear in their show.

Jason: It's incredible how, under so much pressure and chaos, the shows still usually look flawless from the audience's perspective. I don't think you've ever messed up, Marcus, have you?

Marcus: *Have I*? Noooo.

Kevin: I can only remember one time, but it wasn't your fault. The shirt buttoned up the back—shirts don't often button up the back. It was a really quick change, and the dresser put the shirt on him backwards, and it was a case where the designer was talking throughout the show, explaining the new collection. And when Marcus walked out, he actually said, "Oh, my God, Marcus. Your shirt's on backwards!" If he hadn't said anything, no one would have noticed.

Marcus: And then there was that time when I was in Milan, I had to wear these tight, suede Vivienne Westwood pants with lots of strings that had to be tied. The dressers started putting them on me, and I said, "Look, this is the wrong way—they're backwards." And the four people dressing me said no, no, no, they're on the right way. And when they finally got them on me and all laced up, they realized that I was right, because the crotch opening was in the back. I was freaking out. There was no time to change and they

told me I had to go out like that. I couldn't think about anything except keeping my ass covered.

Kevin: That wasn't *my* show, thank God.

PATRICK McMULLAN
MTV Fashion Loud
1996

117

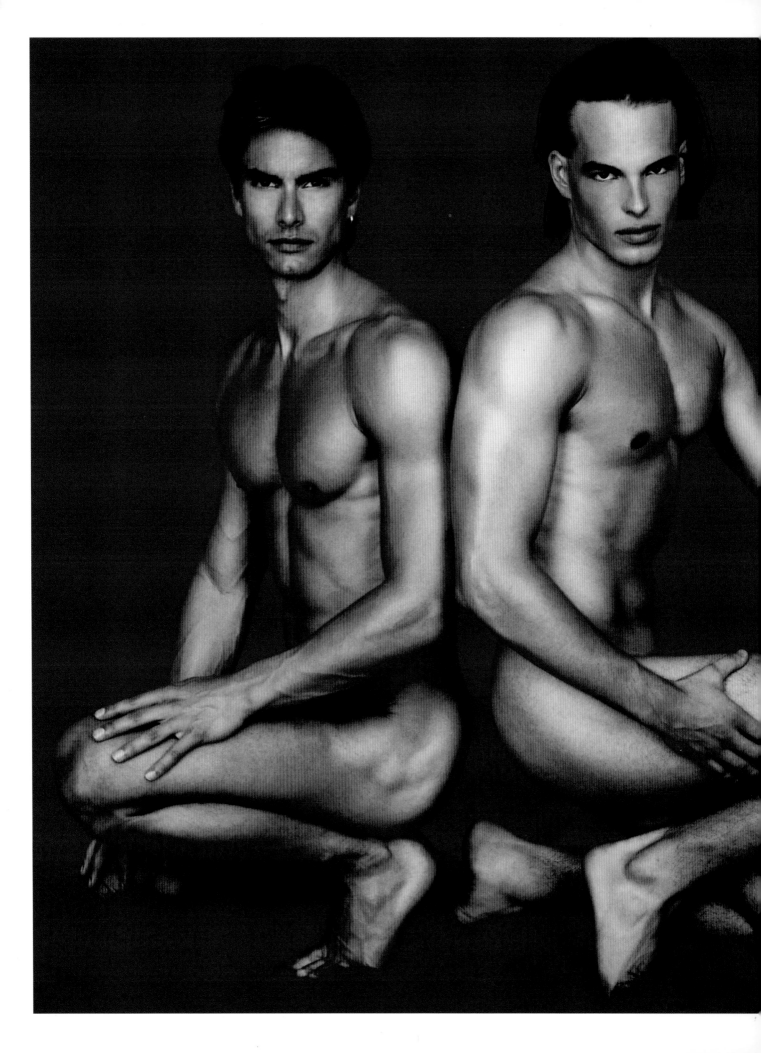

When I began modeling, I knew Marcus as the most famous male model in the world. I idolized him professionally, as he has made it much easier for me to break into the inustry. Now, I am fortunate enough to call him my good friend. There is nothing I look forward to more than my nights out on the town (whatever town in the world it may be) with Marcus. He has an incredible sense of humor—a master joke-teller. When he goes through his arsenal I'm always left sick from laughing so hard (or maybe it's the Jack and Coke) . . . Joel West

JUDSON BAKER
New York, 1996
PETA campaign

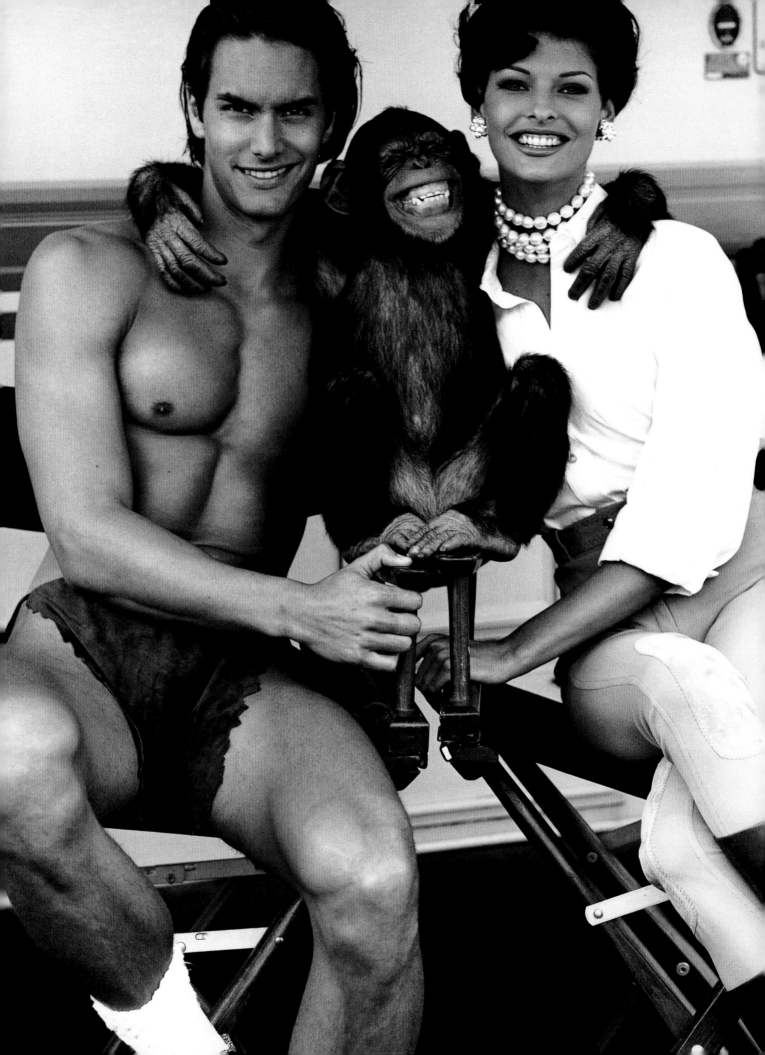

Superwomen on Superman

"As the sitting progressed, Jesse (the chimp) cultivated a jealousy of Linda. On occasion, she would defiantly turn to Marcus and steal a kiss, clearly signaling that he was her domain. Her pleasure was evident. With each kiss her toes would curl." Rocco Laspata and Charles DeCaro

"He is really very down to earth. A good person who is completely not affected by this business, even though he is the most successful male model, ever. He's also a lot of fun to hang out with."

Toneya Bird

121

"Marcus can look intimidating, but once you get close to him, you can see he's a real sweetheart. He has a heart of gold and is a big teddy bear underneath it all."
Naomi Campbell

"During the Versace campaign, Marcus was incredibly creative, professional, and supportive. I couldn't have done it without him. . . . And I never peeked!"
Stephanie Seymour

"He's a stud muffin!"
Isamar Gonzalez

122

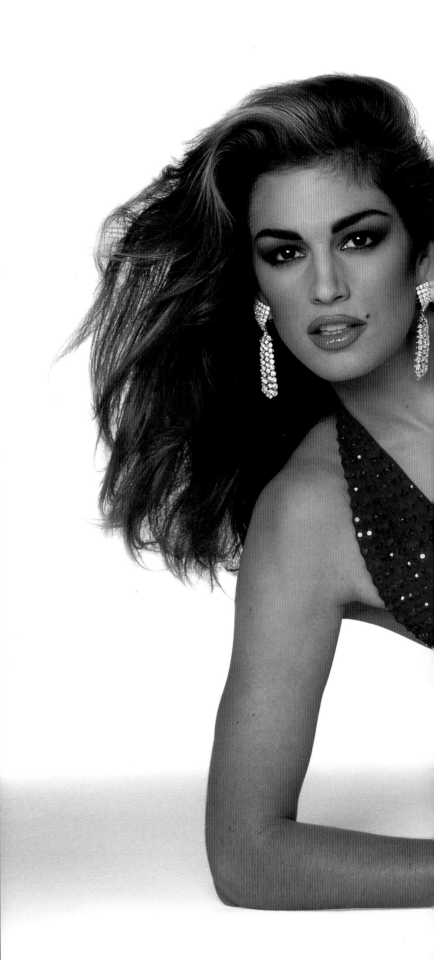

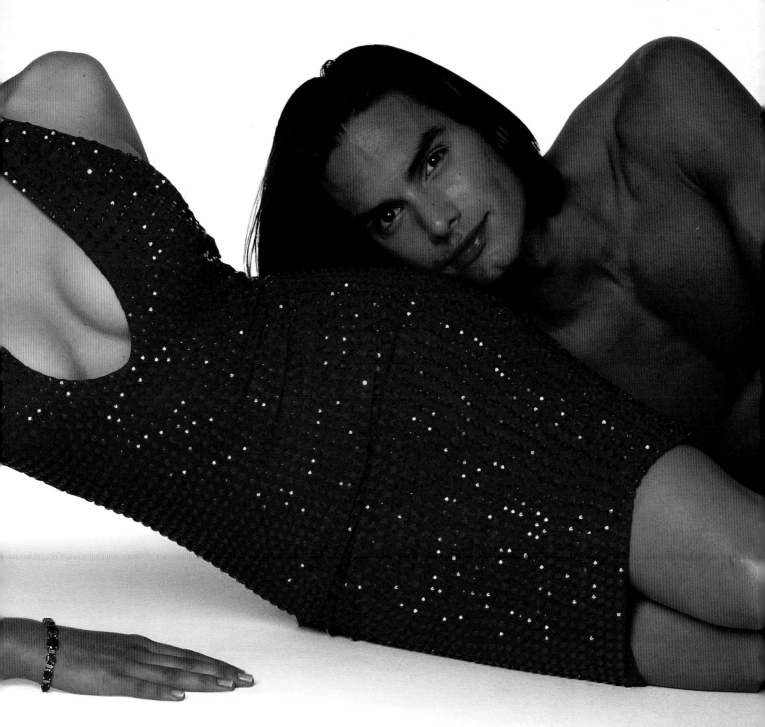

FRANCESCO SCAVULLO
Marcus & Cindy Crawford
Courtesy of Hearst
Corporation

Left, top to bottom
MARCUS, KATE, & NAOMI
New York to Sweden, 1997

MARCUS & STEPHANIE
New York, 1993

ISAMAR
New York, 1997

Left to right, top to bottom:
Mell Flagner, London;
Stephanie Seymour, New York;
David, Rome; Rome; Shalom
Harlow, 1995 CFDA Awards;
Rosemarie's wig, Paris; 1996
Academy Awards; Veronica
Webb, 1996 APLA; Toneya Bird
& Corey Reed (Patrick
McMullan); Cameron & Claude
Montana; Elizabeth Berkley,
1996 APLA; Maureen Gallagher,
Halloween; Southampton
Model Olympics (Patrick
McMullan); Julia Ortiz & Liv
Tyler; *Interview* magazine shoot;
at home, New York; Maureen
Gallagher (Patrick McMullan);
C23 show (Patrick McMullan);
at home with Örjan Jonsson,
Stockholm; Donald & Goofy,
Euro Disney, Paris; Structure
show (Patrick McMullan); Gary
and models, Southampton
Model Olympics (Patrick
McMullan); Rosemarie &
Simone, VH1 Awards; Kate
Moss.

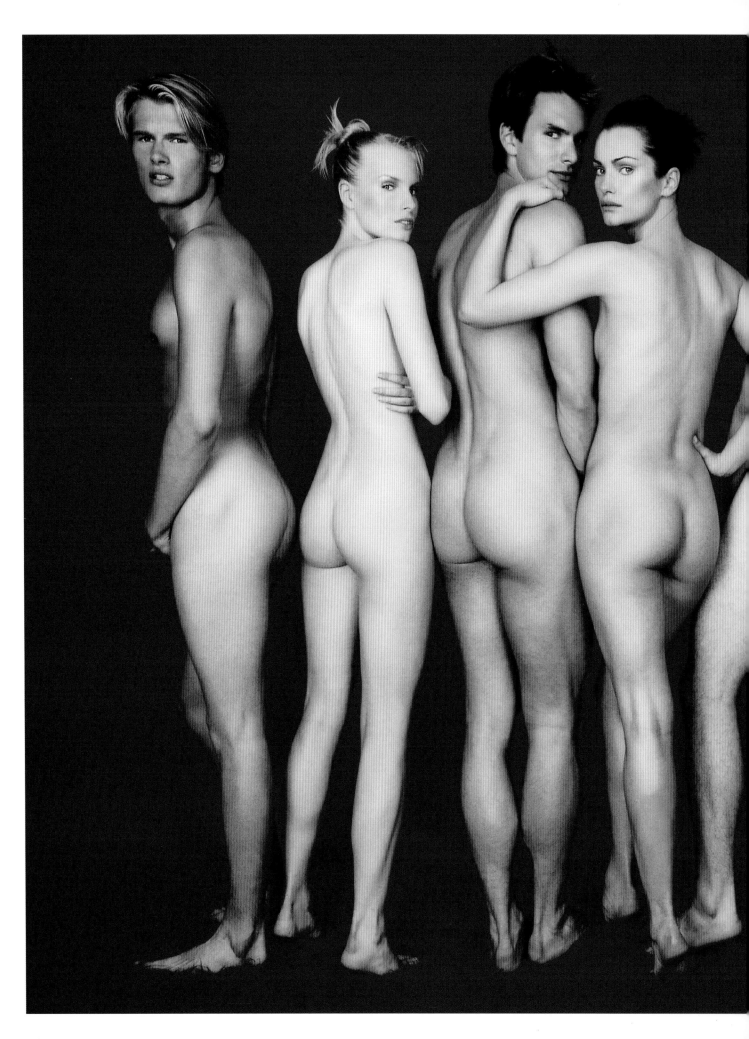

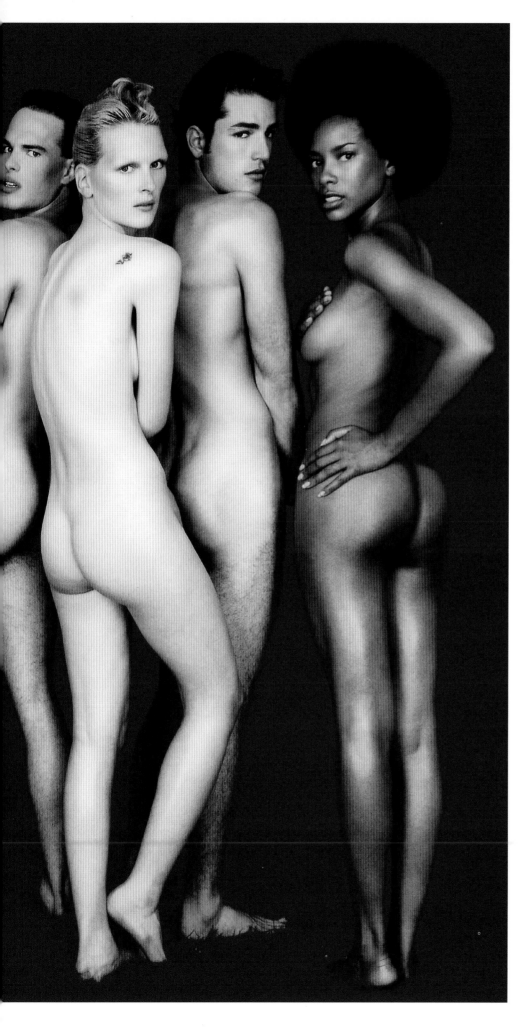

Anybody who would toss their clothes off in Times Square to protest fur during Fashion Week has guts. Marcus's marvelous looks are matched by a heart of gold.

Dan Mathews, PETA [People for the Ethical Treatment of Animals]

JUDSON BAKER
New York, 1996
PETA campaign

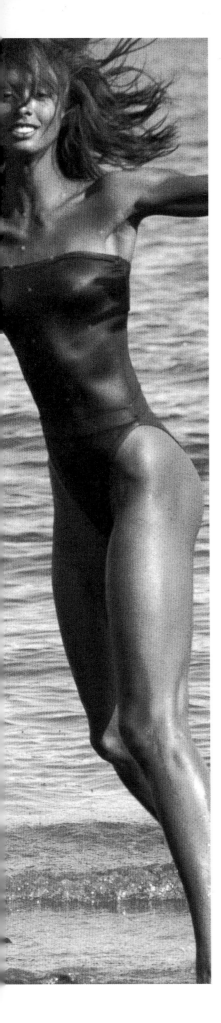

Uncomplicated:
Catherine Hardenborg

Below right, photo by Patrick McMullan (Ex-girlfriend #2)
We met in Israel on a job in 1992. He was unlike any male model I had met before. He took his success very easily and with no attitude at all. He's very down-to-earth and uncomplicated; always himself without the diva attitude that you might expect from a guy with his success. He's the same sweet guy out in public as at home. When he doesn't work, he loves to catch up on his sleep and works out regularly to keep his good physique. He has no hangups about food—eats pretty much everything that comes his way. If more people in the industry would follow the example of his easy attitude, it would be a far better environment to work in.
Love, Cat

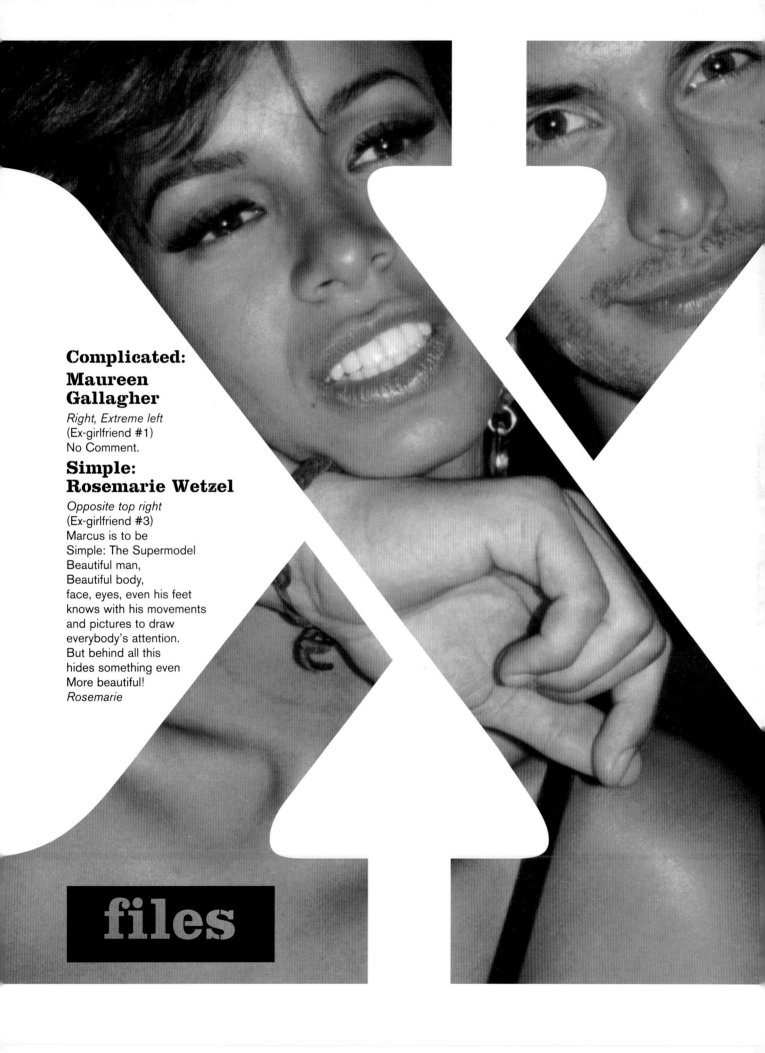

Complicated:
Maureen
Gallagher
Right, Extreme left
(Ex-girlfriend #1)
No Comment.

Simple:
Rosemarie Wetzel
Opposite top right
(Ex-girlfriend #3)
Marcus is to be
Simple: The Supermodel
Beautiful man,
Beautiful body,
face, eyes, even his feet
knows with his movements
and pictures to draw
everybody's attention.
But behind all this
hides something even
More beautiful!
Rosemarie

files

Elegance by Valentino: Since Marcus is the quintessential male model, it is not difficult to dress him. I envision the best-dressed man in a four-button, single-breasted, chocolate-brown, silk mohair tuxedo with a satin lapel, and a white, point-collar, pique oxford shirt with silver studs and cufflinks.

130

PATRICK McMULLAN
New York, 1995
CFDA Awards

New Rules, New Era

seven

133

Pages 134–137
RANDALL MESDON
New York, 1997

Jim Moore Looks Ahead
Fashion Director, *GQ*

Men's fashion is finally breaking out of its mold. Men are paying more attention to themselves, enjoying it, and are flourishing because of it. This sense of self-awareness has, in turn, fueled a new fascination with self-expression and personal style. The fashion industry has picked up on and responded to this signal, and has launched into it, full throttle. Designers see an entirely unexplored frontier opening up before them, and are inspired to push the envelope and test the boundaries of what men will wear.

This is not a fleeting trend, but we also can't expect men to run before they can walk. In relative terms, men's fashion is making greater leaps than women's, but not at nearly the same speed. In general, men have always been uncomfortable with having to make too many choices about their wardrobe, so while designers are creating very new styles, they are also moving men along slowly and comfortably. Designers enjoy this slower pace because they can experiment with the subtleties of design. It's also a refreshing change from the constant pressure of women's fashion to create drastically new trends every season. Men are not yet at the point where they are buying a new wardrobe every season, but they are beginning to grasp the concept of new styles and seasonal trends. They are buying new pieces to accessorize and mix with their existing wardrobe, to update their look, and to make their clothes more of an extension of their personal style.

The forefront of men's fashion is based on the classical and the traditional. Consider the suit the foundation of menswear. Despite predictions, we have not seen the death of the suit. On the contrary, it has many lives. And what we're seeing now is a complete revolution. It's now all about the fit. If I could, I would scream from the mountain tops that men have to find the perfect suit. If they do, they will get a million compliments a day. Men have to figure out what style works for them and looks good on them. First and foremost, a suit must be fitted—not necessarily a skinny suit, but a beautifully tailored suit. A slim suit is always more flattering, no matter what your body-type. It holds you in, and gives you a sense of confidence. A baggy suit won't hide anything, but instead will emphasize flaws by making them look bigger.

My first suggestion would be to buy a custom-made suit, but if that's too expensive there is also a great selection of moderately priced suits previously unavailable. The best way to start is to go to a store with someone whose opinion you trust and who likes to shop. When you find a designer or brand that fits you, always stick with that. And remember not to have it altered in the store. Instead, find an expert tailor and have it fitted perfectly to you.

"Casual Fridays" have become an established ritual in most offices, but now that men have realized that it's okay to care about their appearance, the likelihood of the whole week becoming casual is slim. There is just no question that a well-dressed man makes more of an impression. Even casual wear should always look pulled-together. Good standards for the casual outfit are a variation of khakis, a polo or button-down shirt, and a jacket that you can throw on in case you have a meeting.

There are a lot of new things to experiment with right now, but a guy can still look liberated in a shirt and tie, it simply depends on how they are worn. Like the suit, I don't see the death of the tie happening in our lifetime—but I also don't see it as the issue. If you wear a navy suit with a navy tie, it's still very elegant, and just as modern and different as wearing a tank top.

The key to feeling more liberated is to undo yourself a bit, and to have the air of confidence that comes from knowing that you look sexy and great.

136

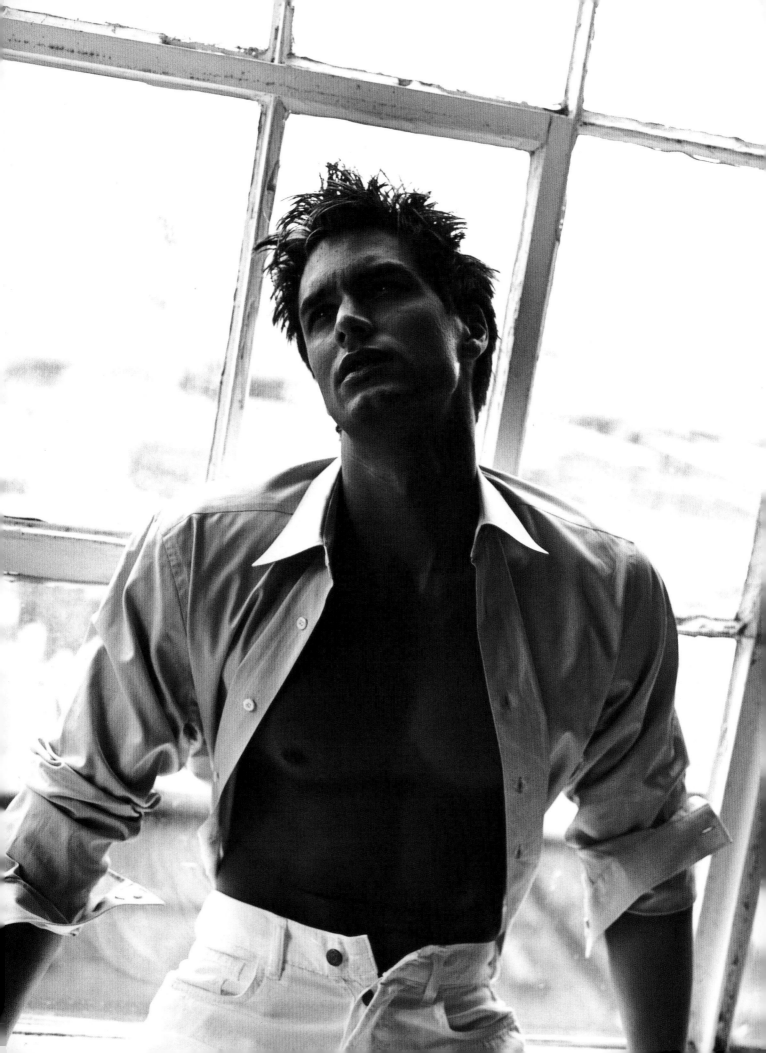

New Rules, Old Rules?
David Bosman

What are the new rules for the future of fashion? Our conservative, tactile world is being forced to evolve or face extinction at the introduction of an infinitely expanding universe of fashion accessories, fabrics, and visuals for the modern human. From personal websites to digital cellular telephones, the new rule of fashion is communication—only with a faster medium and a larger audience. The balance between "high tech," "high touch," and "high visual" is producing the energy that will fuel the fashion industry into the next millennium. Models orbit designers in a new unlimited medium, which we have traditionally called "fashion." Style art, and sex, once conveyed through marble and canvas, are now conveyed through 0's and 1's, that are both accessible and relevant, and yes, increasingly sensual. It is in this balance of virtual and actual that the new rules of fashion will be defined, but be it the Internet television, a one-off boutique, a new fabric or designer; the old rules will always apply. It is those who are adept, even evolved enough to master them who will make the new rules: Marcus Schenkenberg.

He has been dubbed by the fashion industry as "the world's first male supermodel." He has been compared by the press to enduring icons from mythic Adonis to Michelangelo's David. He has been interpreted through the lenses of most of the world's greatest photographers. His unprecedented body of work as a male model has redefined the very definition of masculinity and in doing so, has pioneered the modern idea of the new male beauty.

By the time I met Marcus, he had already been courted by the most powerful agencies in New York. The model empires, whose walls were lined with generations of the model industry's ruling class, threw rose petals under the heir apparent's feet, and made him offers far beyond my means at that time. As the owner of a young boutique agency, the world's first to specialize in men, I had only a dream, a vision, and an interpretation of the future of men's fashion to offer. The day Marcus Schenkenberg joined Boss Models was a coup d'etat.

I had my first dinner with Marcus in New York. I don't remember what we ordered that night, or even what was on the menu. I was a little numb, a little insecure. I only recall, to my surprise, that I truly liked him as a person. As we talked, I shared my personal aspirations, and he did the same. In retrospect, I know that we both

> **"Early on, I realized that modeling was the new-age Hollywood and Marcus was its leading man. The future of men's fashion will forever be built on at least one cornerstone, among others—the name of Marcus Schenkenberg."**

139

instinctively sensed that the whole of our dreams would be greater than the sum of the parts.

His faith in the agency then, and loyalty since—almost unprecedented in an industry *full* of solicitation—has seen him through coveted covers and campaigns. Before him, even the most successful male models only served as backdrops for their female counterparts. Marcus has had an enormous impact on the position occupied by male models not only in fashion, but in advertising, entertainment, and popular culture. Marcus's pervasive reach has made him into a modern icon whose likeness has saturated global popular culture and transcended the fashion industry's inner circles: Gianni Versace featured him on the cover of his book; a quick search for his name on the Internet search engine, *Yahoo!,* will yield hundreds of "unauthorized" websites created by his fans in many languages, from many countries; his trademark leather pants are on display in the Fashion Café; *E! Entertainment Television* produced a thirty-minute special highlighting his career; and *People* magazine has named him one of the world's fifty most beautiful people—just to name a few. But beneath his mythic status and above all, Marcus is a gentleman which, to me, is everything.

I am often asked what makes a supermodel, specifically a male supermodel. After years in the industry, the most complete answer I can give is that those who know Marcus, *know*. Like any Hollywood star or living legend, it is a quality which often eludes words and can only be fully expressed in photographs or in person. Early on, I realized that modeling was the new-age Hollywood and Marcus was its leading man. The future of men's fashion will forever be built on at least one cornerstone, among others—the name of Marcus Schenkenberg.

As the past continually proves to be prologue, I again find myself a little numb and insecure faced with the daunting task of writing a fitting tribute to a friend who has played such an integral and central role in both my personal and professional life. While in the throes of reading and rereading every word ever written about Marcus, I was invited to the theater, on the spur of the moment, by Bob DeBenedictis, my business partner for the last nine years. At the very beginning of the play, a letter that Oscar Wilde had written to someone he considered to be a true Adonis, struck me that he could well have been writing about Marcus today: "Your slim gilt soul walks between passion and poetry. I know Hyacinthus, whom Apollo loved so madly, was you in Greek days."

When something so beautifully written can be so perfectly applicable over a century after the ink has dried, the subtle distinction between the old and new becomes less clear.

This Page, Right, Page 138
MICHAEL TAMMARO
New York, 1996

140

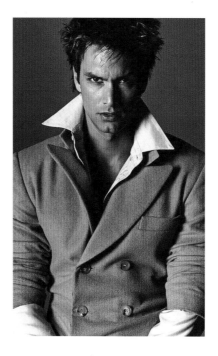
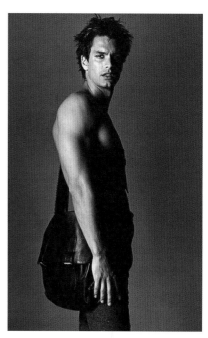

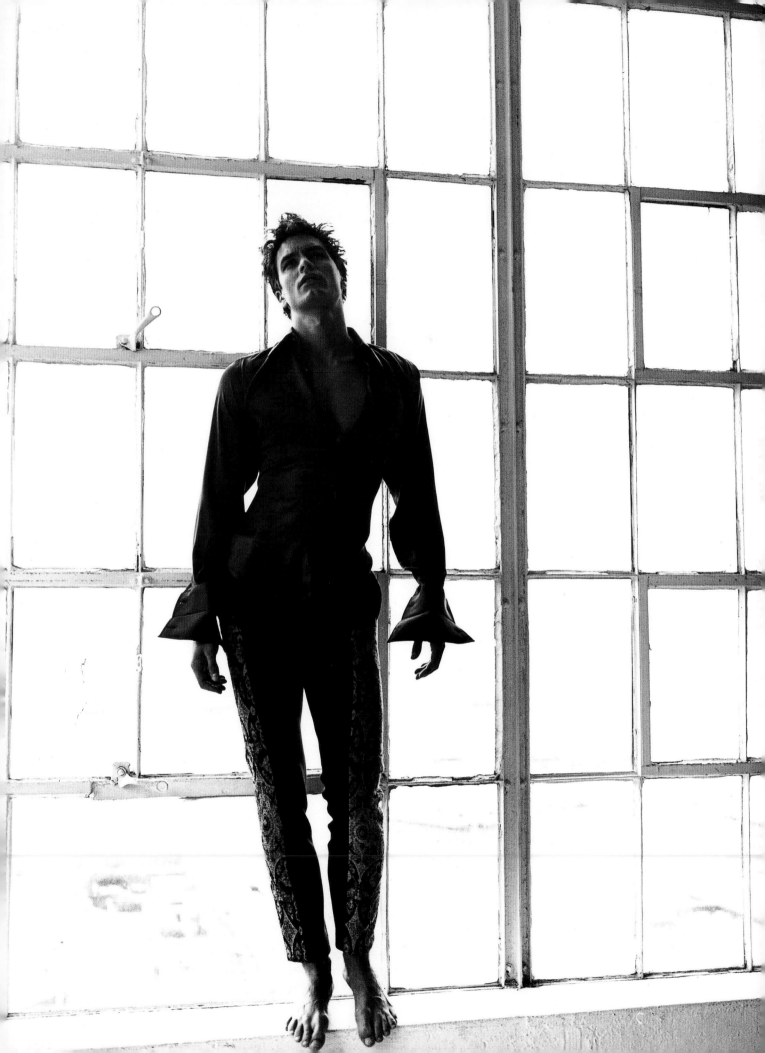